Open Frontiers: *The Mobility of Art in Black Africa*

Index of Art in the Pacific Northwest

1. *West African Sculpture* by René A. Bravmann

2. *Barnett Newman:* Broken Obelisk *and Other Sculptures* by Harold Rosenberg

3. *Crooked Beak of Heaven: Masks and Other Ceremonial Art of the Northwest Coast* by Bill Holm

4. *Art of the Thirties: The Pacific Northwest* by Martha Kingsbury

5. *Open Frontiers: The Mobility of Art in Black Africa* by René A. Bravmann

Open Frontiers: *The Mobility of Art in Black Africa*

By René A. Bravmann

Published for the Henry Art Gallery
by the University of Washington Press
Seattle and London

Open Frontiers: The Mobility of Art in Black Africa
was prepared as the catalogue for an exhibition
held at the Henry Art Gallery, University of
Washington, January 7–February 11, 1973.

Copyright © 1973
by the University of Washington Press
Printed in the United States of America

Library of Congress Cataloging in Publication Data

Bravmann, René A
 Open frontiers.

 (Index of art in the Pacific Northwest, no. 5)
 Issued in connection with an exhibit at the
Henry Art Gallery.
 Bibliography: p.
 1. Art objects, Primitive—Africa, West. 2. Art
objects—Africa, West—Catalogs. I. Henry
Art Gallery. II. Title. III. Series.
NK1087.B72 745 72-11532
ISBN 0-295-95245-8
ISBN 0-295-95254-7 (pbk.)

Photo Credits

Photographs of pieces number 41, 43, and 46 are
by Al Monner, courtesy of the Portland Art
Museum. All other exhibition photographs are
by William Eng. The photographs in the
Introduction are by the author.

Colophon

The text of this book was set in various sizes of
Helvetica light, medium, and bold. The book
was printed on Strathmore Impress text and cover.
Composition by Typoservice, Indianapolis;
offset lithography by the University of Washington
Department of Printing. The clothbound edition
was bound by Lincoln and Allen, Portland, Oregon.

Designed by Douglas Wadden

Foreword

René A. Bravmann's *Open Frontiers: The Mobility
of Art in Black Africa* is the fifth publication in the
Henry Art Gallery's series, Index of Art in the
Pacific Northwest, and the second volume by the
same author to treat African art in Northwest
collections. His first, *West African Sculpture,*
began this important documentation. *Open
Frontiers* is distinguished by the inclusion of
field photographs which provide an additional
aesthetic and historical dimension to the in-
dividual pieces, and by Bravmann's text, which
brings the most recent and innovative historical
methods to bear on a complex subject. Professor
Bravmann writes with the authority of direct ex-
perience. At this writing, he has returned to Africa
for a year of research and fieldwork on the tradi-
tional arts of the Bobo Bwaba and Dyula of the
sixteenth-century town of Bobo-Dioulasso, Upper
Volta.

This volume, and the exhibition that accom-
panies its publication, is part of the Henry
Gallery's continuing program in ethnic arts. These
arts, part of mankind's common culture, are
richly represented in Northwest collections. We
wish to recognize the contribution of PONCHO,
whose grant-in-aid made possible both this
volume and an earlier one in the series. Without
the responsible and concerned assistance of
PONCHO, these significant studies could not
have been published.

Spencer Moseley
Director, School of Art
Acting Director, Henry Gallery

To my parents

Acknowledgments

Many have shared in making this exhibition and publication a reality. To list all of them individually would be far too great a task, but I would like to acknowledge those who have given of themselves far beyond the call of duty. My deepest thanks to Paul and Clara Gebauer who not only responded to my many questions but who also afforded me several warm and wonderful days at their home in McMinnville. My deepest appreciation to Dr. Richard E. Fuller, Director of the Seattle Art Museum, Mr. Thomas Maytham, Associate Director of the Museum, and Pauline Adams, the Museum's Registrar, for their generosity and support of the exhibition. Thanks are also due to Dr. Francis J. Newton, Director, Rachel Griffin, Curator, and Pauline Illo Eyerly of the Education Division, Portland Art Museum. A very special note of gratitude to Eugene Burt, Alfred Izevbigie, and Norman Skougstad, graduate students in the History of Art at the University of Washington, and to Professor John B. Donne, for their help in mounting the exhibition. My thanks to Linda Haverfield for her considerable help in pulling the manuscript together. LaMar Harrington, Assistant Director of the Henry Gallery, and her staff are to be congratulated for extraordinary efforts all along the way. Without the generous financial support of PONCHO the exhibition and catalogue could not even have been conceived. Finally, but not least, thanks to my wife Stevie for her encouragement and help and to my children Paul and Rachel who infused a dimension of sanity into my life during a very hectic publication and exhibition schedule.

Introduction

That considerably more is known about the art of Africa today than was ten years ago can hardly be denied. The subject of the visual arts on the African continent has been re-evaluated, and a number of new methods of study and analysis have been undertaken. African art itself has become so accepted a part of man's artistic heritage that examples appear in virtually every museum, where cultures have felt the need for such institutions: indeed, it has become chic to collect, trade, and verbalize about African art. There is a decided frenzy associated with the increasing discovery of these arts. Museum curators are sifting through their collections with renewed vigor in order to put together yet another exhibition from Africa. Historians and anthropologists, who at one time ignored the arts as a serious avenue of research, are now doing an about face. The effect has been the rise of an increasing body of literature, resulting in a fund of information (and misinformation), which is beginning to tap the range and diversity of Sub-Saharan African art. New artistic types and styles are being documented while others are being further explored. On the surface this situation would seem to offer much that is positive. After all, enthusiasm can lead to discoveries, a heightened sense of awareness, and ultimately, one hopes, to greater sensitivity and knowledge. Enthusiasm can also, however, lead to the perpetuation of misconceptions and the hardening of outdated and archaic thoughts.

Certainly one of the most glaring distortions that has affected the notions and writings of those who have concerned themselves with the arts of Africa, whether they are researchers in the humanities or the social sciences or more casual observers, is the concept of the tribe as a closed artistic entity. Art has been viewed almost consistently as a purely tribal phenomenon. The perimeter of tribal styles, it is claimed, coincides completely with the extent of the tribe. The equation becomes, roughly, one tribe=one style. But is this not a dreadful oversimplification? Or, to put it more strongly, is this not a decided falsification of the very life of art in Black Africa?

Simon Ottenberg, in a recent lecture at the University of Ghana on the subject of *Anthropology and Aesthetics* (1971, pp. 5-6), addressed himself briefly to this question:

The equation of *tribe* with aesthetic style in Africa by Western scholars has also hampered proper comprehension. I believe that the idea of African tribes originally grew out of a Western ethnocentrism, in some cases, racism. Africa was seen as an arrangement of different cultures, each in its own geographic area, each with its own language and art styles. . . .

There has been too much of a nineteenth century interest, deriving from biology, in the morphological classification of cultures, in which a tribe is the equivalent of a plant or animal; in the case of cultures this becomes the basis of misunderstanding as much as of comprehension. We are back in the natural history museum again.

Much has been said by those who have written on the arts about the "universe of the tribe," its closed nature, and the high degree of insularity that tends to characterize African cultures and their arts. They see art as a by-product of closed systems; as forms meant to function solely in support of those cultures in which they were created. There is, of course, no doubt that the visual arts in Black Africa are intensely functional, for the effete realm of art for art's sake has not yet become an arena of expression, but does this mean that traditional art is invariably bound to its tribal universe? Is art so completely conservative, so fully tied to its cultural base, that it cannot move between cultures, both over space and through time? The outdated, and indeed racist, concept of "frozen cultures" has long been discredited, and yet it still seems to invade our thinking with respect to the arts. It is certainly true that all African cultures preserve their own identities and artistic traditions, but have these cultures been cordoned off from one another or been closed to outside influences and the stimulation of surrounding cultures?

The overwhelming weight of opinion is that the tribe and its associated art forms are a hermetically sealed and static entity impervious to outside stimuli and fertilization—that tribal styles are monolithic and self-contained aesthetic

wholes. Described in such a manner, African cultures appear to suffer from a massive case of *rigor mortis.* Some apologists, who see the blatant negativism of such a view, have suggested that this idea actually grows out of the very nature of the studies accomplished to date. They claim that it is the influence of anthropology, a discipline whose followers have tended to focus upon "the tribe." Others suggest that it is the only reasonable and expeditious way by which the artistic riches of the African continent can be classified and studied in an orderly fashion. Yet whatever excuse is offered, it is glaringly evident that this fundamental concept is a distortion of reality and thus indefensible. As the history of Africa itself defies such a notion, it is obvious that those interested in the arts have been at the very least ahistorical, and in some cases antihistorical.

To think historically in terms of the arts, many of which are created out of perishable materials, can prove quite difficult. But a historical point of view does not necessarily entail a grand reconstruction of the history of African art over many centuries. If this were the only means of establishing an "art history" we should have stopped before we had begun, for reconstruction over time requires that the arts survive, and the task, in terms of African art, would have been essentially unfruitful. The facts of history for shorter periods of time cannot, however, be ignored, and Africa has been characterized by a degree of historical dynamism which must be dealt with. Historical research by both Westerners and Africans, using written sources and oral literature, has revealed a past that denies the static qualities normally ascribed to African societies and their art forms.

The fallacy of the notion that the tribe and its artistic traditions are indisputably one, free to lead an isolated existence, is dramatically revealed when tested either in the field or through intensive secondary source research. That the tribe has not existed as an independent organism can be seen in the numerous forces impinging upon tribal societies. One may begin with such obvious and massive historical experiences as the

rise and fall of state systems, international trading links, and the wholesale dispersal of populations. There have also been many more subtle avenues of culture contact and change. The geographical proximity and the mixing of peoples defy the notion of a series of isolated pocket cultures. Local, regional, and interregional trade routes have touched all cultures of Black Africa. In virtually all regions, there has been mobility of artisan groups, specialists working in a wide variety of techniques and media. The movement of shrines, spirit forces, and individual religious specialists and believers has made the area of art and religion an extremely fluid one. These avenues of mobility and change destroy the "walls" that have been built about African cultures and their arts and point to the very open frontiers, both geographic and conceptual, that exist between them.

To demonstrate the openness of tribal life—that open frontiers are in fact a key feature of African cultures and their artistic traditions—I would like to use two regions, the area of the Cercle de Bondoukou and west central Ghana and the grasslands of Cameroon, as cases in point. Although limiting myself to these two culture zones, I in no way mean to imply that these cases are exceptional. They are, I believe, simply two instances of open frontiers, a concept that is applicable to a lesser or greater degree in all of Black Africa.

Probably the most important historical force that has affected the arts in these two areas is the process of state building and expansion. In the Cercle de Bondoukou and west central Ghana the penetration of the Ashanti resulted not only in Ashanti political domination but also in a very sophisticated form of "cultural imperialism." Every non-Akan culture was deeply affected by the Ashanti presence, culturally, linguistically, and artistically. In assimilating these diverse cultures, the Ashanti distributed numerous gifts of regalia, art forms tied to politics and political etiquette, and thus among the Nafana, Kulango, and Degha one finds virtually every art object normally associated with the Ashanti. The Nafana chief of

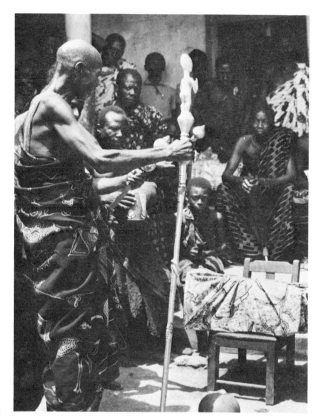

Fig. 1. The Nafana chief of Tambi and his royal entourage adorned with Ashanti art forms

Tambi (fig. 1), seated on an *assipim* chair and flanked by the queen mother of the state and his chief linguist, could easily be mistaken for an Ashanti or Akan ruler. He wears all of the regalia—a *kente* cloth, *bemufena* or arm bangles, and the *abotere* or royal fillet—of a typical Ashanti chief. His sons, holding *akofena* (state swords), occupy the same positions as royal pages in Ashanti proper.

The same gamut of regalia can be seen throughout the Kulango states of Seikwa and Badu, two chieftaincies that were established by the Kulango in the late seventeenth century. The chief linguist, known among the Kulango by the Twi term Okyeamehene, is seen in figure 2, reciting a libation before one of the blackened stools of the state of Badu. Dressed in a typical Ashanti embroidered cloth and baring both shoulders as a sign of respect to the spirit of the stool, he invokes the spirit force not in his own language, but in Twi. The linguist staff held firmly in his right hand was carved in Denkyira, an important Akan state about one hundred miles south of Badu. The Degha have also adopted all of the regalia normally attributed to the Ashanti. The treasury of the Tekydiatena family of the Degha state of Longero includes six state swords with gold-leafed handles (fig. 3). These swords, used for swearing allegiance to the Omanhene or paramount chief of Longero, were purchased from Bron and Ashanti artisans over the last seventy-five years.

Kulango, Nafana, and Degha states and villages became islands of Ashanti fashion. Once they had adopted the political and social organization of the Ashanti, it was imperative that the art forms associated with Ashanti culture also be acquired.

Fig. 2. The Okyeamehene or chief linguist of the Kulango state of Badu addressing the covered blackened stool of the state

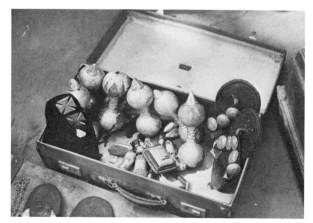

Fig. 3. Six state swords with gold-leafed handles from the treasury of the Tekydiatena family of the Degha state of Longero

11

The Ashanti helped to facilitate this process by continuously sending gifts to these cultures in return for their support in wars and for maintaining allegiance to the Asantehene. The remnant of an *assipim* chair seen in figure 4 is still preserved by the Bamboihene whose family received this gift from one of the wing, or subordinate, chiefs of Ashanti at the turn of the century. Although obviously no longer functional, it commemorates the ties established between the Degha and Ashanti at the beginning of the eighteenth century. The elegantly carved gold-painted linguist staff at the village of Badu (fig. 5) was a gift presented to Badu by the Akyempemhene of Kumasi. A continual flow of gifts between Ashanti and its tributary states served as an important aspect of its policy of assimilation.

The circulation of gifts among rulers was also a prominent feature of the states in the interior of Cameroon. Carved ivory tusks, dyed cloths, pipes, a wide range of ceramic ware, and even masks were distributed in great quantities. Many of the items in the present exhibition are, in fact, examples of this prevalent phenomenon in the grasslands.

Even during the colonial period, open frontiers were evident. In the Gold Coast (Ghana), the British attempted to deal with local chiefs by using a communication link based entirely on local tradition. Noting the importance of the linguist and of linguist staffs in traditional society, they created an object known as the "message stick," which was referred to by the Ashanti and all cultures in west central Ghana as the *oban-poma* or government stick. Figure 6 illustrates such an *oban-poma* being held by one of the linguists of the Bron state of Wenchi. It was given to the state of Wenchi in the second decade of this century by the regional commissioner of Ashanti for services rendered British authorities by the Wenchi state. The work hardly compares to a traditional linguist staff in aesthetic terms, for it is merely a stick decorated with a band of German silver and topped by a silver knob carrying the stamped symbol of the imperial lion. During the colonial period *oban-poma* became the most

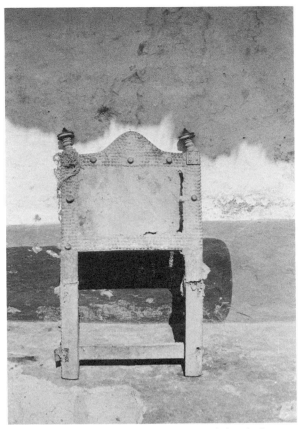

Fig. 4. An early twentieth-century *assipim* chair presented to the chief of Bamboi by an Ashanti military commander

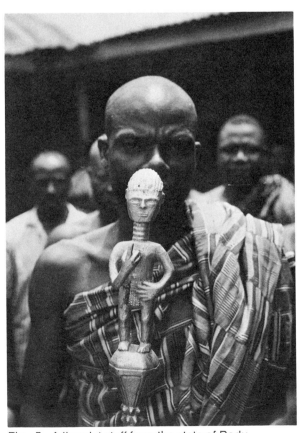

Fig. 5. A linguist staff from the state of Badu presented to this Kulango town by the Akyempemhene of Kumasi

important linguist staffs in local states. They served as the direct communication symbol between chiefly authority and the colonial government, and no chief could have an audience with a representative of the British government without carrying such a stick. Although they have lost importance since independence, *oban-poma* are retained as symbols of the past and of a period of history still very well remembered.

Little attention has been paid to the vitality of trade, the importance of trade routes, and the dynamics of market systems with respect to art. It is clear, however, that much of the vitality of art has been due to these economic features. Local, regional, interregional, and even international trade networks have touched virtually all cultures in Black Africa and have had a direct effect upon the material culture and the arts of these societies. Particularly notable examples of an art form that resulted from an international trade network are the *yaawa* or brass bowls of North African origin found in central Ghana. Figure 7 shows a detail of one of several North African brass objects at the Bron town of Nsawkaw, a fifteenth-century Kufic inscribed brass basin that rests on a stone outside the queen mother's compound. The basin is one of many items that came via the trans-Saharan trade routes to the very edge of the Akan forest. When it arrived at Nsawkaw is not known, but the Bron inhabitants claim that it is as old as the state itself; indeed, they claim that the original ancestors of Nsawkaw came down from the sky in this bowl. Although obviously an import, it has become tied to the very core of Bron life and history, serving as a shrine that is propitiated not only at the annual yam festival but regularly throughout the ritual year. Such imports are so crucial to the Bron of Nsawkaw that they are maintained by an elder and propitiated in the same manner as the most "traditional" shrines at Nsawkaw. Figure 8 depicts the Kuruwaasehene, the chief or keeper of the bowls, pouring a libation of local gin to the second most important brass bowl at Nsawkaw.

Examples of international trade connections may at times be limited, but this is less the case

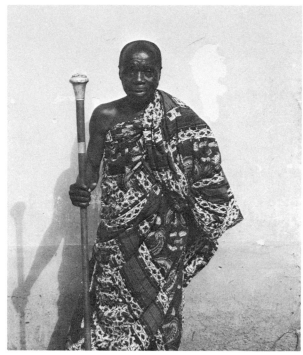

Fig. 6. The *oban-poma* of the Wenchi state

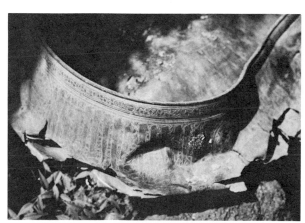

Fig. 7. A fifteenth-century North African brass basin with Kufic inscription at the Bron town of Nsawkaw

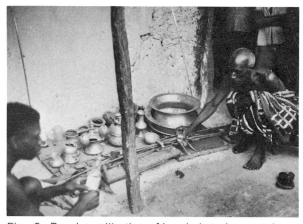

Fig. 8. Pouring a libation of local gin to imported North African brass pieces at Nsawkaw

with the interregional movement of art. Hausa
blankets have been a common import in the
Cercle de Bondoukou and west central Ghana
since the nineteenth century, when the main trade
routes between the Akan forest and the northeast
(Nigeria) flowed through Hausaland. The Hausa
blanket, No. 22 in this catalogue, is an example of
the type of prestige blanket avidly sought by
rulers.The interior of Cameroon, which was tied
to the Benue River valley by numerous important
trade arterials, enjoyed many imports from that
region. Jukun or Wukari blue stenciled and dyed
cloths were a prime luxury commodity traded into
the grasslands for the courts of Tikar chiefs.
Figure 9 depicts the chief or Fon of Babanki-Kijem
dancing in the courtyard of his palace with some
of his many wives. Serving as a backdrop to the
festival area is one of the huge Jukun cloths
acquired by trade. The cloth is an important
decorative item as well as a symbol of the rank
and status of the Fon. Interregional trade routes
were a major source for the circulation of art
everywhere in Black Africa.

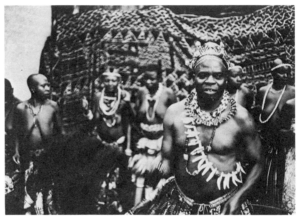

Fig. 9. The Fon of Babanki-kijem dancing with
his wives before a large, imported, Jukun dyed
cloth

 Clearly the most dynamic aspect of trade,
however, has been the local market. Its impact
upon the distribution of products, ranging from
foodstuffs to utilitarian art forms, has been
enormous. In large towns the market is a fixed
phenomenon and draws buyers and sellers from
throughout the countryside. In areas where there
are no sizable urban centers, markets move from
village to village in a cyclical fashion. In both
instances, however, the circulation of goods is
ensured. Large towns in the Cercle de Bondoukou
and west central Ghana, such as Bondoukou and
Wenchi, are veritable hubs of activity on any day.

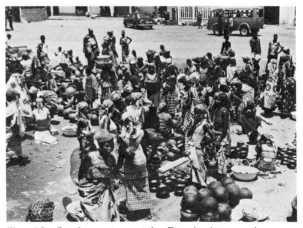

Fig. 10. Degha pottery at the Bondoukou market

 The markets are organized on the basis of the
goods available, with foods in one section,
ceramics in another, and so on. What on the sur-
face may appear to be chaotic is, in fact, very care-
fully regulated. At Bondoukou the master Degha
potters occupy a prominent section on the
southern edge of the market (fig. 10). At times one
can find several hundred pots of various types
being sold to local non-Degha women as well as to
lorry drivers who will truck them as far as one

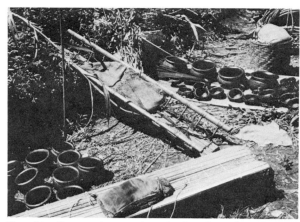

Fig. 11. Bamessi ceramics at a local market on the Ndop plain in the grasslands of Cameroon

hundred miles in any direction. At Bamessi markets, on the Ndop Plain of the grasslands of Cameroon, avidly sought Bamessi ceramics are carried away on litters by virtually all peoples of the region (fig. 11). Tightly woven Bafut head-covers and baskets (fig. 12) are found in all Bafut markets and are yet another product easily available to those outside of the producing society. The market as a hub of economic and social life in Black Africa has been all but ignored by those interested in the arts, and yet it stands as perhaps the most obvious example of the how and why of artistic mobility.

Art can also become mobile when individual artisans or whole groups of artisans ply their expertise over a wide area. This occurs in both regions under discussion and may well be a factor to be reckoned with everywhere. The Dyula of Bondoukou monopolize the dyeing industry throughout the Cercle de Bondoukou and the adjacent portion of Ghana. This they do by circulating from village to village collecting raw spun cotton and carrying it back to their dyeing pits in Bondoukou town. The Dyula are the acknowledged masters of the art of dyeing cotton fiber, a specialist skill that has been under their control ever since they established residence in this region in the sixteenth century. The quarter of the Dyula dyers at Bondoukou is constantly active, with cotton samples coming from all cultures within a radius of fifty miles of the town. Even where these dyers do not manage to penetrate, Kulango and Degha weavers from distant villages make the journey to Bondoukou in order to contact them. The dyer (fig. 13) uses both locally made indigo drawn from the leaves of the *gara* bush and imported vat indigo from Germany or England. The dyeing may be done either in extremely large Degha containers, often three feet in diameter, or in the traditional dyeing pits.

Fig. 12. Bafut headcovers and baskets on display in a Bafut market

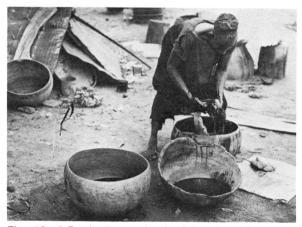

Fig. 13. A Dyula dyer, using both local and imported dyes, dipping spun cotton fibers into a dying vat

When the mobility of an artisan group is limited by the nature of its specialty, another aspect of dispersal is encountered. Pottery centers, for example, attract consumers from many miles away who come to purchase at the source. Bamessi villages and towns are constant stopping points for itinerant traders or individuals who are seeking the high quality workmanship of the Bamessi potters. Known throughout the grasslands as the most skilled workers in clay, Bamessi women have a virtual monopoly on the production of ceramics within the interior of Cameroon. Using a variety of rudimentary tools they are able to produce an incredibly large range of pottery types. The water container being modeled in figure 14 is merely one example of Bamessi wares.

The Degha occupy the same prominent position in the field of ceramics in the interior of Ghana and the Ivory Coast that the Bamessi do in Cameroon. Located primarily in villages along the banks of the Black Volta River and its tributaries, the Degha control the finest clay beds in the region. Degha villages are consistently visited by Kulango, Nafana, Dyula, Ligbi, Hwela, and Bron who desire to obtain their work. Even the smallest Degha village has a monthly communal firing which may include one hundred to one hundred and fifty pots. At large centers, such as Bondakele, a typical firing session occurs bimonthly and may yield two hundred items. The Degha, like the Bamessi, do not know the potter's wheel, but the craftsmanship of these women is such that they achieve an almost perfect symmetry in their wares. Every Degha woman is a potter unless she is physically or mentally incapacitated, and it is an art which young girls begin to learn at the age of four or five. No glazes are used, but many items are tinted after firing (fig. 15). Shortly after the firing process, the still warm pots are taken off the firing stack and dipped into a vat filled with a tint made from local herbs and roots. Although Degha potters generally remain in their own villages, there have been a few exceptional cases of Degha families moving to a Bron town in order to produce specifically for that community.

Ironworking is yet another specialist skill in both of these regions. The Numu, a people who have spread from the upper Niger Valley to the very edge of the Akan forest, clearly dominate this area of artistic expertise. Prior to the importation of European hoes, knives, and so forth, no town or village could do without the services of the Numu. Even with access to imported iron products, the people of this region still depend heavily upon the Numu for adze blades, agricultural implements, and ritually oriented items such as bells, clappers, anklets, and armlets used within certain masquerade contexts. The Oku blacksmiths of the central Cameroonian grasslands occupy the same position as the Numu. Shovels used for agricultural purposes and as a form of traditional currency (fig. 16) were one of the leading products of the Oku smiths. Like the Numu, the Oku are regarded as a pariah class, feared because of their knowledge of metalworking and fire, and because of the magical associations of their craft.

Fig. 14. A master Bamessi potter modeling a highly prized water container

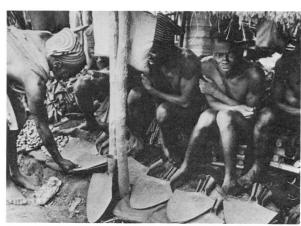

Fig. 16. Purchasing shovels made by the Oku blacksmiths of the Cameroonian grasslands

Where cultures settle in close proximity to one another, or where they are interspersed, as is true in these two areas, the possibilities for artistic interchange are extremely high. Under such circumstances the factors leading to the movement of an art form may be subtle and yet discernible. The woven caps of the Nsungli of Cameroon have been adopted by all neighboring peoples because of their fine workmanship and originality of design. Figure 17 illustrates several Bamunka men wearing Nsungli caps while dressed in their own locally made, dyed, and embroidered gowns. Figure 18, which illustrates a carved figure type known among the Degha as a *Kayere,* is an example of a sculptural form adapted by the Degha from the Ashanti to the south. The Degha admit that they borrowed the Ashanti tradition of the *Akua-ba* but changed the functions and conceptualization of that type to fit their own needs. Unlike the *Akua-ba,* the *Kayere* may be used as a guardian or medium for a shrine or, more commonly, as a surrogate figure for a dead twin. Rather than maintaining the abstract form of the *Akua-ba,* the Degha converted it into a far more naturalistic image. The need to humanize the form is extended to clothing it when it is in actual use.

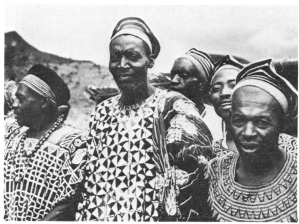

Fig. 17. Nsungli caps being worn by Bamunka men

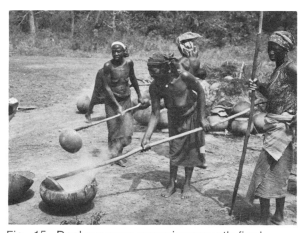

Fig. 15. Degha women removing recently fired pots from the fire, to be tinted with a mixture of local herbs and roots mixed in a watery base

Fig. 18. A Degha *Kayere* held by its owner; such a piece is given beads and dressed when used traditionally

17

We have considered at length some utilitarian art forms and their movement, but the number of ritual items that have been subject to intertribal mobility is also impressive. Large and spectacular shrines have been imported into west central Ghana from the very northern portion of the country, an area referred to as the "factory of the gods." At Apemkro, a very insignificant Bron village some ten miles east of Wenchi, is a shrine of Kankamea. The homeland of Kankamea is the village of Birifor in the northwestern corner of Ghana, and the shrine at Apemkro is a "child" of the parent spirit. Kankamea was brought to Apemkro some forty years ago after a number of disasters struck the village. Local deities had not been able to deal effectively with these problems, and it was decided that a more powerful shrine was needed to protect the village. Purchasing a shrine is a major undertaking, requiring not only a considerable outlay of goods and currency but also that the artisans from the homeland of the shrine be transported, housed, and fed during the construction process. The altar of Kankamea at Apemkro (fig. 19) has six guardian figures and is covered with a plaster facing. The shrine is almost identical in style to the one at Birifor since spiritual and artistic uniformity are necessary prerequisites to the mobility of a shrine of this type.

Masking traditions may be subject to the same kinds of mobility as shrines. In the Cercle de Bondoukou and west central Ghana there exist two masking traditions that typify this sort of dynamism. The Bedu masquerade, which deals with a host of societal problems ranging from crop failures to social disunity but is specifically devoted to the eradication of illness and disease, has been adopted by many villages and towns in this area. Although the origins of the tradition go back no further than the 1930s, and to the Nafana village of Oulike, it has spread quickly to the Kulango, Degha, and Hwela. Positive in its orientation, the masquerade is publicly performed and has proved to be an effective deterrent to social problems. The public appearance of the Bedu masks occurs in November and December,

and these large and brightly colored monoxyle carvings usher in a month of joy for the inhabitants of villages that own them (fig. 20).

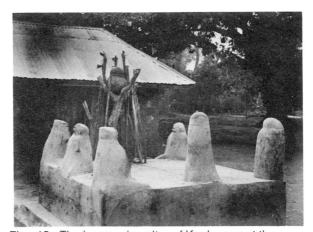

Fig. 19. The impressive altar of Kankamea at the Bron village of Apemkro

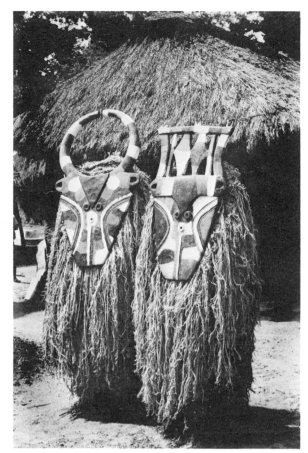

Fig. 20. The pair of Bedu masks from the Nafana quarter of Bondoukou

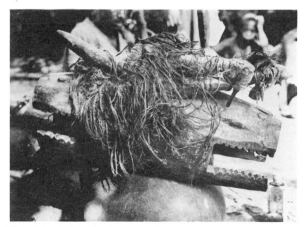

Fig. 21. A double-headed Gbain mask at the Degha village of Sagabile, imported from the Muslim town of Sorhobango

It may be argued that exoteric masquerades would quite logically spread among neighboring cultures, and yet the same may be true of esoteric masking traditions. The Gbain, an antiwitchcraft cult utilizing a horizontal fire-breathing mask, has moved swiftly among cultures in the Cercle de Bondoukou. According to Louis Tauxier, the chief French officer in this region during the 1920s, the Gbain was associated at that time only with the Muslim Dyula and Hwela. Between 1920 and today this tradition has spread to all non-Muslim cultures in the area, where it is acknowledged as having been imported from either the Dyula or the Hwela. One can discover, almost to the exact year, when and why a Gbain mask was purchased by a particular Nafana, Kulango, or Degha community. The mobility in this case is not only geographic and cultural but also conceptual for the masquerade is Muslim in its orientation. Nonetheless, it has been adapted successfully by non-Muslim populations. Protection against witchcraft is probably a necessary element in all African cultures, and the need for powerful counteragents is great. The double-headed Gbain mask in figure 21, owned by the Degha village of Sagabile, was purchased at the important Hwela Muslim town of Sorhobango.

The openness of African cultures to the arts and the mobility of art within them is obvious. The avenues by which these frontiers have remained open are many. It can be said that there are, in essence, three basic ways in which art and art forms are accepted interculturally.

The first and simplest avenue of artistic mobility seems to be "product" oriented and is associated with purely utilitarian articles. All pottery traditions in the grasslands of Cameroon have been overshadowed by the superior Bamessi ceramics. In west central Ghana and the Cercle de Bondoukou, the Degha monopolize the manufacture of pottery. All other pottery traditions in this area either have been abandoned, as in most Bron communities, or are retained in only a residual manner, as in Nsawkaw. A clearly superior art form may often have this effect upon surrounding traditions, particularly when the

possibilities for successful economic and aesthetic competition do not exist.

The second avenue of mobility is in operation when a particular art type or product becomes part of the cultural fabric of a recipient society. This occurs when imported art forms become associated with the very core of a culture and play a part in its historical, political, or ritual life. The prestige cloths from the Benue valley found in virtually all Tikar states, and the Islamic brass bowls at Nsawkaw, are but two examples of this kind of movement. This form of artistic mobility remains in the category of "borrowing" only because the production of the art forms is retained by the originating cultures, who continue to supply whatever additional or replacement items are needed.

The third, the rarest, and the most complete method of artistic movement is accomplished when a society fully rationalizes a once imported art form. In these instances assimilation is so complete that the recipient culture assumes not only the use but also the production of the tradition. By virtue of the total acceptance of the tradition, the culture is then free to interpret it so that it conforms to its own artistic and aesthetic standards. This phenomenon is most dramatically expressed in the tradition of the Degha *Kayere,* which derived from the Ashanti *Akua-ba.* Such complete absorption will generally require a considerable amount of time; yet in some instances, as in the case of the Bedu masquerade, we find that this mask type has been completely taken over from the Nafana by such groups as the Kulango and Degha. Both of these cultures today carve, paint, and control every aspect of their own Bedu masquerades.

While the degree of cultural and artistic exchange and interchange may vary, it is undeniable that such mobility has long existed in Black Africa. The tribe is not a closed world but an entity that has been open through trade, personal mobility, and political and cultural expansion. Artistic dynamism has been assured because of these open frontiers.

Notes on the Catalogue

Since the exhibition and catalogue argue against the basic tribal format commonly used to classify the art of Africa, I have structured both according to two geographical and cultural zones: the Cercle de Bondoukou and west central Ghana, and the grasslands of Cameroon. Within each of these two broad sections the art objects have been listed according to type and to the mobility which these types display rather than by cultures. The types range from ritual and large-scale works, associated with a wide series of social functions, to purely utilitarian forms.

Data furnished by other researchers are acknowledged in the entries. Numbers 41, 43, 46, and 52 from the Portland Art Museum, and number 22 (Private collection), although not available for the exhibition, are represented by large wall-mounted photographs. Previous publications of pieces in the exhibition are noted [within brackets] at the end of individual entries. The largest dimension of each object is given in inches.

The Cercle de Bondoukou and West Central Ghana

The Cercle de Bondoukou in the northeastern Ivory Coast and the adjacent portion of west central Ghana lie at the very northern edge of the Akan forest, stretching from the town of Nassian, at the western limits of the Cercle de Bondoukou, to Kintampo, in Ghana. It is an area characteristic of the southern savanna of West Africa, with dense vegetation consisting of tall elephant grass and occasional trees. The savanna land is fertile, being generously watered by the Black Volta, Tain, and Subin rivers. Its generally flat contour is dotted intermittently by gently sloping hills: the Banda range, which stretches north-south through the Nafana state of Banda; the rising terrain to the west and north of the town of Bondoukou; and the hilly country around the trading center of Kintampo. The region circumscribes an area approximately fifty miles in depth and seventy-five miles from east to west.

Situated as it is at the southern fringe of the savanna country and at the edge of the forest, this zone has occupied a critical geographic position in the history of the interiors of both the Ivory Coast and Ghana. Over the last three hundred years it has served as a major crossroads for the movements of peoples coming from all directions. Although limited in size, it is ethnographically complex. Representatives of three West African language subfamilies have been resident in the area for several centuries. The oldest cultures, those who claim original occupation of the soil, are the Dumpo and the Bron, cultures of the Kwa language subfamily. Their oral histories assert that they are autochthonous to the area, having settled either by descent from the sky or emergence from the earth. The oral histories of the Bron and Dumpo, despite their poetic qualities, are to be taken seriously, and indeed all other cultures presently in the area corroborate them. As yet there has been too little archeological fieldwork done to enable us to date the origins of the Bron and Dumpo in this zone, but both were certainly in residence by the late sixteenth century when the first immigrant cultures arrived.

The earliest influx of non-Kwa peoples included three representatives of the Mande family.

By the sixteenth century the Dyula, Ligbi, and Numu were already resident. The Dyula and Ligbi, Islamized trading peoples originating from the Upper Niger River valley, established a number of trading communities, of which the most important was the great market town of Begho. The non-Muslim Numu, specialists in ironworking and living symbiotically with the Dyula and Ligbi, settled in these newly developed communities. The economic viability of this entire border zone was deeply affected by the immigrant Mande, and from the seventeenth century to the present the commercial life of the region has been dominated by Mande trading elements.

The first representatives of the Gur family of cultures arrived in the area in the late seventeenth century. At this period three Gur peoples, the Nafana, Degha, and Kulango, moved south and further complicated an already dynamic ethnographic environment. Degha immigrants, having left their homeland in northern Ghana as a result of state-building pressures by the Mossi, settled along the banks of the Black Volta River. The Nafana, a Senufo-related people, left the southern Senufo country of Jimini and settled to the west and east of the Banda hills. From the very northeastern corner of the Ivory Coast came the Kulango, who were driven south by the rising state of Dagomba. By the end of the seventh century the cultural complexion of the area was fixed. The heterogeneity has continued, augmented up until the present by the settlement of peoples such as the Dagarti, Lobi, Sissala, and Hausa since the early twentieth century.

Because of the great number of cultures involved, the history of this area has been complex. Serving as a buffer zone of small chiefdoms lying between the more highly organized Akan states of the south and the savanna states to the north (such as Gonja and Dagomba), the region was directly involved in the rise and fall of those polities. At various times the area came under the direct control of the Ashanti, but the situation was always a fluid one, for the history of the states and smaller chiefdoms of the Cercle de Bondoukou and west central Ghana is marked by a continuous series of rebellions. In addition, the area was in a pivotal position for the trade network between the Niger bend and the gold-bearing forest of the Ashanti. The towns were important entrepôts where northern traders exchanged their products for the gold and kola from the Akan, and to which trading representatives and middle men from the forest journeyed to consummate these important transactions.

Trade ranging from local exchanges to international ventures, the changing fortunes of surrounding state systems, the internal political history of the smaller states of this region, and a continuous movement of peoples all helped to produce a dynamic historical situation. Cultural and artistic interactions between Muslims and non-Muslims, and among peoples belonging to three distinct linguistic and cultural streams, typify this region. The intensive degree of interaction resulted in a finely spun and complex web embracing all cultures in the area. The objects in this exhibition which come from the Cercle de Bondoukou and west central Ghana reveal the mobility of art forms, both utilitarian and ritual, and are a reflection of the cultural and historical energy of the region.

The Cercle de Bondoukou and West Central Ghana

Approximate Distribution
of Major Cultures

– – –	Kulango					
						Degha
～～～	Nafana					
★	Numu					
○	Dyula					
□	Dumpo					
-·-·-	Bron					

GHANA

IVORY
COAST

● Kumasi

● Accra

VOLTA R.

IVORY COAST

GHANA

BLACK VOLTA R.

CERCLE DE BONDOUKOU

○ ○ ○ ○
○
○ ○
○ ○
○

● Tambi

Kyende ● ～ ○ Sorhobango

Kanguele ●
★
Oulike ○
Bondoukou ★
○ ○
○
Sampa ●
○

○ Jammra

Bondakele ●

Bungazi
Banda ●
★ ○ ○
★

Jogboi ●

Bamboi ●

Longero ●

New Longero ●

Kintampo ○

BANDA
HILLS

TAIN R.

WEST CENTRAL GHANA

★ ★
★
□ □

|||> Namasa
Old Begho

Atomfoso ●
★ ★

★ ★
★ Nsawkaw
○

SUBIN R.

Nchira ●

○ ★
Seikwa
●

Badu
★ ●

Wenchi
○ ○
○

● Apemkro

Offuman ●

Kumasi
90 miles

Techiman
○ ○

Nkoranza
○ ●

Scale

0 ——— 10 ——— 20 Miles

1. Bron; Royal Chair; Brass, Wood, Goatskin;
H. 29 ¼″
The *assipim* chair is one of the most conspicuous items of royal furniture among the Akan cultures of Ghana and the Ivory Coast. Tied to political office and to important spiritual positions, the *assipim* appears not only at state occasions but also at the most esoteric rites carried out among the Akan. Its paramount importance is reflected in the fact that it generally serves as the seat for the blackened state stools of the Akan when these appear covered in royal cloths in public. The histories of Ashanti and Bron states reveal that many *assipim* chairs were given as gifts or tokens of thanks or sold outright to the chiefs of non-Akan peoples. Indeed this was true for every non-Akan culture: the Kulango, Degha, Hwela, Nafana, and Numu on the northern edge of Ashanti and Bron country. Among these cultures the *assipim* occupies the same high status, and only rulers may acquire and sit upon these beautifully worked objects. This example, which is in a rather battered condition and of considerable age, is a typical *assipim* consisting of a wooden chair frame, a seat of goatskin, and brass studs.
Gallery Nimba

2. Kulango; Personal Stool; Wood, Tin, and
Brass; W. 20″
The Kulango of Seikwa and Badu in west central Ghana are the southernmost representatives of this important Gur culture which stretches from southern Upper Volta to the Ashanti forest. In existence since the sixteenth century, these two Kulango states have been deeply affected by their Akan neighbors, the Bron and Ashanti. The Kulango of Seikwa and Badu speak Twi, the language of the Ashanti and Bron, as their second language, use Akan day names, and have patterned their political and social institutions directly upon those of adjacent Ashanti peoples. The cultural borrowings are undeniable, and it is therefore not surprising to find numerous Akan art forms among them. This is particularly true of those objects associated with politics, that is, regalia, and the entire gamut of Akan regalia may in fact be seen in both Seikwa and Badu. This stool, formerly owned by the Seikwahene, is one of numerous examples which he had commissioned in Kumasi, approximately 120 miles to the southeast. The Kulango of Seikwa have never adopted the tradition of carving stools, unlike the Kulango of Badu, and thus even today must import these objects from outside the state.
Private collection

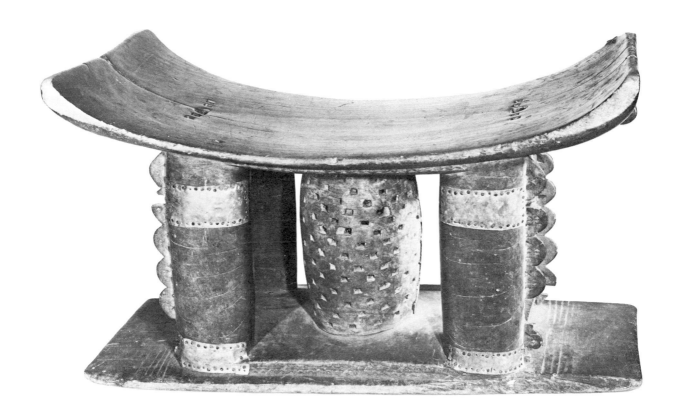

2. Kulango, personal stool

3. Lobi, Personal Stool, Wood and Brass Tacks, H. 5 ¾"

As already mentioned, one of the key features of the west central portion of Ghana and the adjacent sector of the Ivory Coast is its ethnographic complexity. For the most part, the cultures in the region have been there since the end of the seventeenth century. There are, however, numerous representatives of other societies, for example, the Lobi, Dagarti, and Hausa, who have settled in the region within the last two to three generations. This Lobi stool, owned by a Lobi farmer and priest in the village of Jammra, was once used by a priest who sat upon it when consulting with individuals who had come to his shrine for advice or help. Identical to the most common stool type carved by the Lobi of north-western Ghana and Upper Volta, it differs from this purely utilitarian form by the inclusion of six brass tacks, which are pounded into the seat of the stool. According to Kwaku Yele, who inherited the work from his father, the tacks mark the object as being ritually significant. The piece was carried from Lobi country to Jammra by Yele's father sometime between 1910 and 1915 when he came south in search of work.
Private collection

4. Ashanti or Bron; State Sword; Wood, Iron, White Clay; L. 13"

Akofena, or state swords, are also a prominent feature of Akan life. Among the Ashanti and Bron there is a profusion of such objects, some serving as messenger swords carried by court couriers and others used for swearing allegiance and for the enstoolment of chiefs. As in the case of royal furniture, *akofena* were frequently given as gifts to non-Akan states. The fifteen state swords at the Nafana state of Banda, for example, were all royal presents from the Asantihene to Banda during the eighteenth and nineteenth centuries. Even foreign deities could receive such an object if its oracular powers had aided the Ashanti or Bron in important wars. Despite the fact that every non-Akan culture in this area has adopted the *akofena* over the last two hundred years, it is an art form that even today is not produced by any of these groups. The Kulango, Nafana, and Degha must commission such works from either Ashanti or Bron artisans.
Gallery Nimba

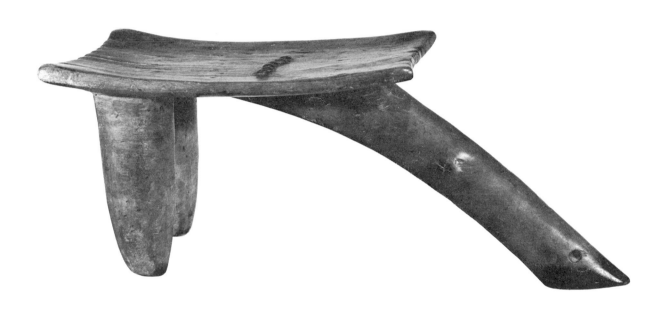

3. Lobi, personal stool

5. Ashanti, Miniature State Sword, Brass, L. 4″
State swords are a vital part of the arts of regalia in all Akan cultures. They are symbols of rank, both political and spiritual; are carried by messengers of royal courts and serve to legitimize the messenger and the message; and in some cases are related to the soul of a living paramount chief. It is rare, however, for an *akofena,* or state sword, to be reproduced in miniature form. This work, from the Degha village of Old Longero, was acquired by the Degha at the turn of the century from an Ashanti caster at Akumadan, some fifty-five miles south of Old Longero. The work depicts a particular type of state sword known among the Ashanti and Bron as a messenger sword or *asomfofena.* On the sheath, which is cast separately from the sword and handle, appears an *abosodie,* a reference to the gold cast symbol normally tied to the sheath of an *asomfofena.* The *abosodie* consists of two small tadpole images, symbols of human fertility and state continuity among the Akan. The raised designs covering the sheath may refer either to the embossed gold symbols that would have been placed upon the sheath of a full-sized sword or to the skin of the ray fish, which was, and still is, often used to cover such items.
Private collection

6. Bron, Gold-Dust Spoon, Brass, H. 11″
Gold-dust spoons *(nsawa)* were a necessary adjunct to all Akan and neighboring non-Akan states whose economies were based on gold dust. They were used to measure the amount of gold dust placed upon weighing scales during traditional bartering sessions and were often highly elaborated artistically. Created by beating brass into thin sheets which were then cut, the *nsawa* could take on any number of basic forms. The handles became works of art and might include any number of geometric designs, from gracefully cut lozenge forms to elegant spirals emanating from various portions of the handle. This example, from the Bron town of Techiman, is an extremely large and beautifully restrained version of the *nsawa.* The surface of the handle is punctuated by two sections of raised circular dots and incised semilunar motifs. Almost identical *nsawa* can be seen in virtually all Bron states and also among the Nafana and Kulango, who acquired such pieces from the Bron and the Ashanti.
Private collection

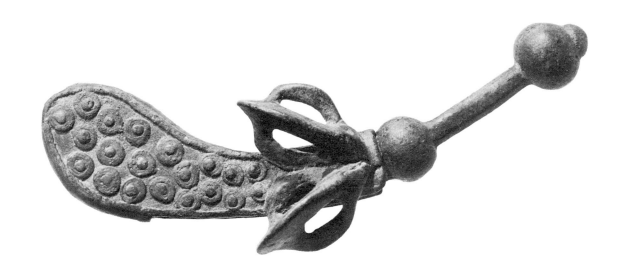

5. Ashanti, miniature state sword

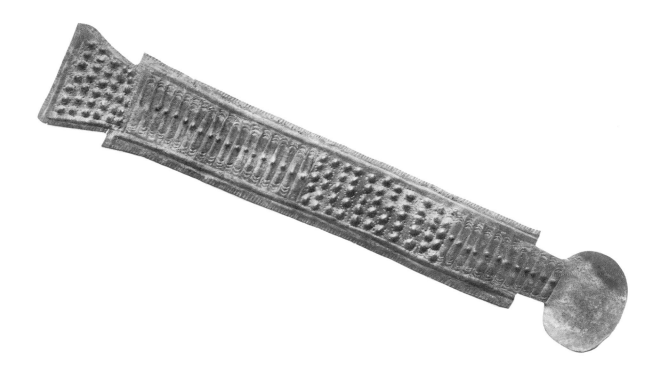

6. Bron, gold-dust spoon

7. Ashanti, Gold-Dust Spoon, Brass, H. 5 ½"
More delicately conceived and executed, this *nsawa,* from the Nafana village of Bungazi, was said to have been acquired in Kumasi in the mid-nineteenth century. The piece consists of eleven coiled tendrils issuing from the upper portion of the handle and is an excellent example of the care and artistic skill lavished upon these works by Ashanti craftsmen.
Private collection

8. Bron, Goldweight, Brass, H. 1 ¾"
Although goldweights are generally viewed as having been created and elaborated by the brass casters of Ashanti, it is clear that many Akan peoples were involved in the development of this tradition of miniature art. The economic base of all Akan states was the prominent gold reserves found throughout the Akan forest, and thus all such states ultimately required gold-weights for the measuring of gold dust. The Bron, who reside on the very northern edge of the Ashanti forest, are yet another Akan culture in which the casting of goldweights reached a very high artistic peak. Practically all of the known weight types of the Ashanti, both figurative and geometric, were also produced among the Bron and may still be seen today in compounds where they are preserved as family heirlooms. This piece, a beautifully cast representation of an *assipim* chair with simulated brass studs, was cast in the Bron state of Wenchi. In quality it rivals the very best pieces produced in Ashanti.
Private collection

9. Bron, Goldweight, Brass, L. 1 ⅜"
The major Bron centers for the production of goldweights appear to have been the towns of Wenchi, Offuman, Techiman, and Nsawkaw. Each was and is a capital town and the major urban center for the Bron state of the same name. They therefore served logically as centers for artisans who produced a wide array of necessary art forms, as well as distribution points for these arts, and many non-Bron and non-Akan peoples acquired items of regalia and objects like goldweights from them. This elegantly cast figure of a scorpion, said to have been cast at Techiman in the nine-teenth century, formed a part of the goldweight collection of the chief of Atomfoso, a town con-sisting primarily of Mande blacksmiths who are known throughout this region, and elsewhere in West Africa, as the Numu. The Numu of Atomfoso, according to their oral traditions, have resided at the town since about the eighteenth century and have adopted many cultural and artistic features from the Bron. Although experts in the field of ironworking, the Numu have never developed a bronze- or brasscasting tradition and thus were dependent upon the Bron and Ashanti for objects like goldweights. Before the introduction of British currency, the Numu used these weights in the same manner as the Ashanti and Bron, and today they are retained as prestige pieces.
Private collection

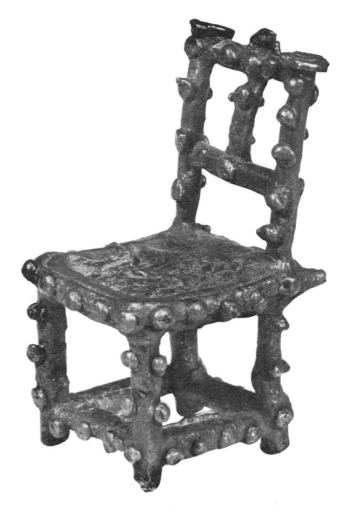

8. Bron, goldweight

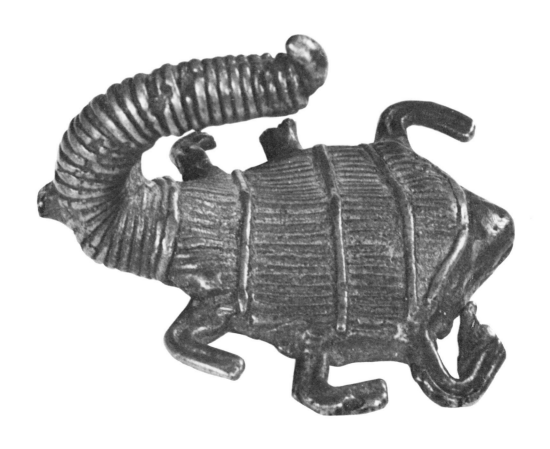

9. Bron, goldweight

10. Bron, Goldweight, Brass, H. 1 9/16″
Cast in the Bron town of Nsawkaw sometime in the first half of the nineteenth century, this superbly worked miniature of a male figure wearing a loincloth formed part of the collection of an Odekuro or headman of the Degha village of Bamboi. The Odekuro revealed that he had inherited the piece from his father, who had originally purchased the weight along with others at Nsawkaw, some thirty miles to the southwest. Its Bron origins are discernible by several stylistic characteristics. The prominent eyebrows and slitlike eyes are basic features of finely cast Bron figurative weights of the nineteenth century. In addition, the relationship of the head to the total body is quite naturalistic, even by western definitions of the term, and this was a clear hallmark of Bron miniature casting.
Private collection

11. Ashanti, Goldweight, Brass, L. 4 ¼″
Small, elegant, and necessary to the traditional currency system associated with gold dust, goldweights were a primary necessity among all cultures in contact with the Ashanti and Bron. The Hwela, who are considered to be indigenous to western Brong/Ahafo and who came under Ashanti control by approximately 1725, have been Ashantized over the intervening years. Collected at the Hwela town of Namasa on the Wenchi-Bondoukou road, this goldweight, representing a swordfish (an animal sacred to both the Bron and Ashanti), was owned by the Imām or Muslim spiritual leader of Namasa. According to the Imām, the work was presented to his father by the Akyempemhene of Kumasi, a wing chief of the Ashanti state. Before the colonial period, Namasa formed part of the Ashanti state and was under the nominal control of the Akyempemhene.
Private collection

12. Ashanti, Goldweight, Brass, L. 2 ¾″
This splendid example of a master musician playing the *atumpan* drum, which is carried on the head of a drum carrier in procession, has been selected not because it is a piece cast in Ashanti and utilized elsewhere (for such data do not exist, and this may not in fact have been the case), but because it depicts an object type, the *atumpan* drum, which has been accepted by many non-Akan cultures in contact with the Ashanti and other Akan peoples of the forest. It is found at virtually every royal compound among the Kulango, Nafana, and Degha and has been recorded even farther north in the divisions of Gonja and among the Dagomba. In all cases where the *atumpan* has been adopted it operates in the same manner as among the Ashanti and Bron. It transmits oral histories, praise poems, and messages of various sorts, and at times it serves as the lead drum in dance ensembles. The *atumpan* continues to "speak" Twi even though the Akanized societies may use this language only as a second tongue.
Seattle Art Museum, Eugene Fuller Memorial Collection, AF11.24

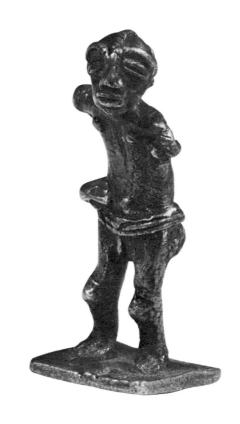

10. Bron, goldweight

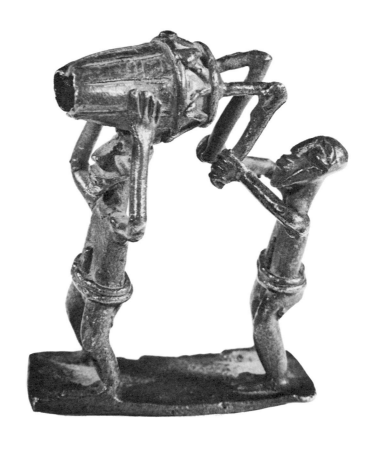

12. Ashanti, goldweight

13. Lobi, Protective Piece, Wood, H. 19"
This carefully carved Lobi head with its stakelike neck is an important carved figure type among the Lobi of Northwestern Ghana and southern Upper Volta. In Lobi country itself such pieces serve a personal protective function, safeguarding the family and specifically the family head. They are placed either in the sleeping room of the family head or on the family altar. The stakelike form of the figure allows it to be driven into the ground for support. Two stakelike heads seen among the Lobi in Wenchi were far less elaborately carved but operated in a similar fashion. The triple scarification marks on either side of the eyes, the helmetlike head (a reference to the calabashes that are worn as hats among the Lobi), and the lip disks are core features of Lobi figurative art. Seattle Art Museum, Gift of Merton D. Simpson, 68.AF11.75

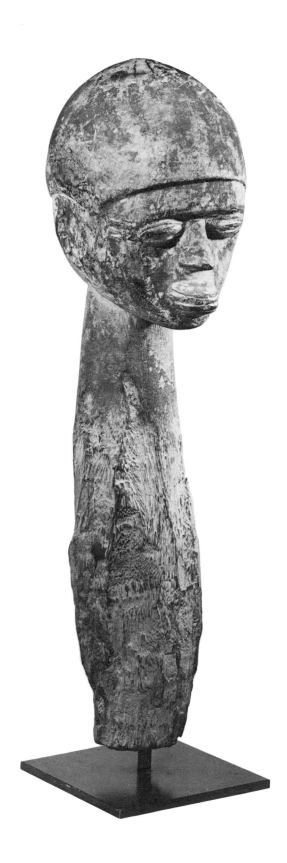

13. Lobi, protective piece

14. Ashanti, Mother and Child, Wood, H. 21″
The theme of the mother and child, with the mother usually seated on either a stool or chair and breast-feeding the child, is often encountered in Ashanti art. Some writers suggest that this may well refer to the queen mother or Ohemaa, while others believe that such a composition most likely relates to the theme of motherhood and the importance of the mother in a matrilineal society. Both attributions are possible, but there are rarely sufficient collection data to allow one to make either assumption with any real finality. This mother and child image, almost identical in style to the female figure with missing child in the Paul Tishman Collection (Sieber and Rubin: 1968, no. 54), was collected in Kumasi. It was said to have been used in a shrine and to have served as a protective figure. An almost identical figure was used by the Numu chief at Atomfoso, nearly one hundred miles to the northwest of Kumasi in the Bron state of Nsawkaw, where it served as an item of royal regalia. The example collected at Kumasi is particularly interesting since beneath the charcoal patina there is a layer of gold paint, further strengthening the assumption that the work might have been used in a royal context before becoming a shrine guardian figure.
Private collection

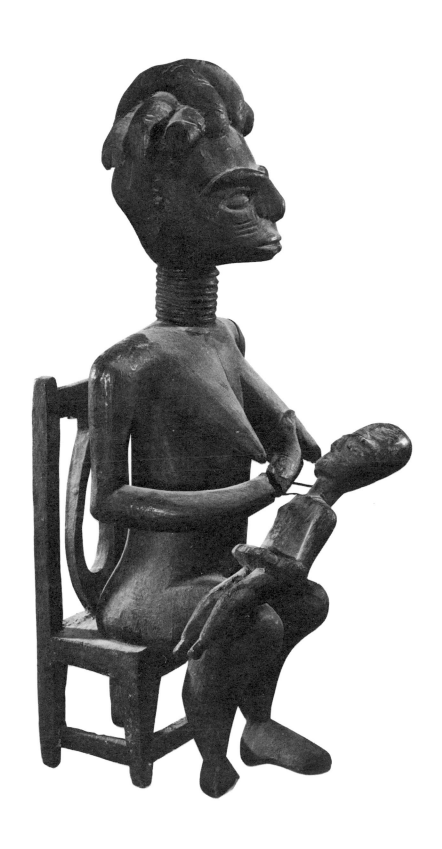

14. Ashanti, mother and child

15. Aowin, Hermaphroditic Figure, Wood, H. 12″
Although previously labeled a Baule image, this carving, with its distinctive flattened face, segmented double-lobed hairdo, and flexed hands touching a beard rendered by parallel vertical ridges, should probably be attributed to the Aowin, who inhabit the very western portion of the Ashanti forest. An Akan culture, the Aowin point to their historical connections with Akan groups farther east, including the Ashanti, and have had important historical associations with the Brong/Ahafo region to the north. Figures in this style were noted in several shrines in Bron country, especially among the Nafana, and were said to have been commissioned from Aowin artists at Enchi. When these imports are used as guardian figures, the Nafana add beads and an occasional amulet in order to beautify them and to make them more effective.
Seattle Art Museum, Eugene Fuller Memorial Collection, AF11.1

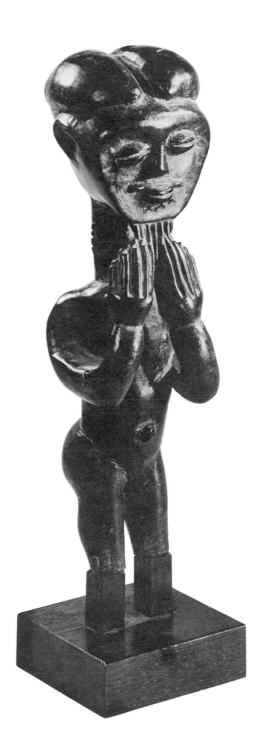

15. Aowin, hermaphroditic figure

16. Akan; Mother and Child; Wood, Enamel Paints; H. 28"

Impressively executed, this mother and child figure with a lavish painted surface of gold, blue, turquoise, and magenta enamel is yet another work possibly associated with the concept of the queen mother. This assumption receives a measure of confirmation from the fact that the mother is seated upon an *mma gwa,* the stool type known universally among the Akan as the female's or mother's stool. In this elaborated form it is restricted in use to women of the highest rank.
Gallery Nimba

17. Baule; Mother and Child; Wood, Glass Beads; H. 16 ¾"

Discarded by the priest of the shrine of Tere at the Kulango town of Badu, this Baule mother and child figure attests to the potential mobility of ritual objects. According to the priest, he purchased the work at Agnibilekrou, an important Agni town north of Abidjan in the Ivory Coast, in the 1920s. It was used in his shrine to promote fertility and operated effectively until about 1960. It was discarded at that time in favor of another figure, purchased in Ashanti. This elegantly carved composition exhibits the typical Baule tendencies toward absolute refinement of details. Such features as the hair style, the scarification marks, the minute strands of beads, and the lavish care devoted to the articulation of the human form are all indications of its cultural origin.
Private collection

18. Degha; Surrogate Figure; Wood, Beads; H. 11"

Like the Kulango and Nafana, two other Gur cultures in west central Ghana and the northeastern Ivory Coast, the Degha have also been dominated historically and culturally by Akan peoples to the south. A host of art types generally associated with the Ashanti and Bron have been incorporated into Degha life since about the first quarter of the eighteenth century, when Degha villages along the Black Volta River were initially brought under the aegis of Ashanti. One of the most prominent

and obvious manifestations of the gradual influence of the Ashanti and Bron on the Degha is an object known as the *Kayere,* a small doll-like figure that may serve as a surrogate image for a dead twin, a doll to promote female fertility, or a guardian piece for a shrine. Also referred to as an *Akua-ba,* the Ashanti and Bron term for such a figure, the *Kayere* is acknowledged to have come from the south. Although functionally identical to the *Akua-ba,* the *Kayere,* which is always carved by Degha artisans, exhibits somewhat different stylistic features. The flattened head and rudimentary body of the *Akua-ba* are interpreted in a much more naturalistic manner. Unlike the Ashanti or Bron *Akua-ba,* the *Kayere,* if cared for correctly, will be oiled and rubbed with either palm oil or shea butter to enhance the surface beauty of the work. [Bravmann: 1970, no. 81]
Private collection

19. Kwahu, Memorial Head, Terra Cotta, H. 11 ¼"

One of the most important diagnostic features associated with the impressive spread of Akan cultures has been the retention of terra-cotta funerary heads used in conjunction with the burial of rulers and important priestly figures. Such items occur among Akan groups as far removed as the Agni of southeastern Ivory Coast, the Nzima of coastal Ghana, and the Kwahu southeast of Kumasi. Terra-cotta heads of Akan manufacture, however, may occasionally be found among the Kulango and Nafana, where they serve not as funerary portraits but as messengers or intermediaries between the priest and the spirit of local shrines.
Seattle Art Museum, Eugene Fuller Memorial Collection, 66.AF11.29

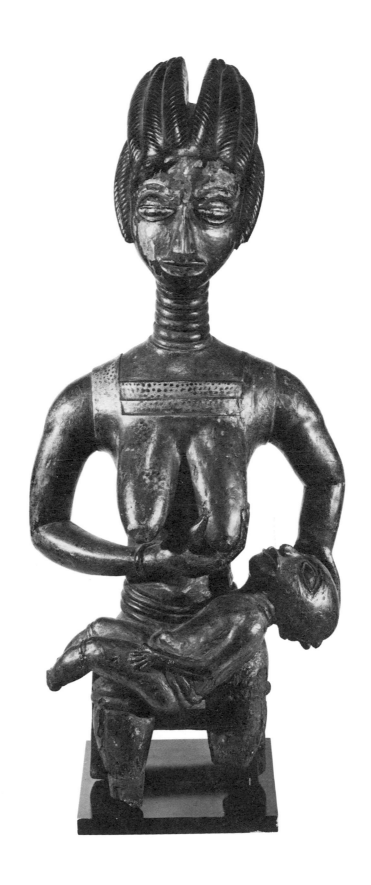

16. Akan, mother and child

20. Paratribal; Bedu Mask; Wood, Ochre, Blue and White Paints; H. 54"

A rather small version of the Bedu mask, this work is an example of a masquerade form that is found among three members of the Gur language subfamily in the Cercle de Bondoukou. The Bedu is used by the Kulango, Nafana, and Degha in public performances meant to curb epidemics, human infertility, and evil in general. Although said to have been a Nafana tradition originally, the masquerade has spread rapidly among the Kulango and Degha because of its positive orientation. According to local traditions, the masquerade began in the Nafana town of Oulike in the 1930s, but in the last generation or so it has been accepted throughout the entire northern section of the Cercle de Bondoukou. No more than two or three carvers have ever fashioned this particular mask form, but their workmanship has been eagerly sought by all. The Bedu is an excellent example of how a single mask type may in fact spread rapidly, in some instances supplanting older traditions, if it is more effective. Typical Bedu masks range anywhere from five to seven feet in height and, as in this case, include a face portion and either horns (male) or a superstructure of two slender vertical posts and a disklike portion at the very top (female).
Dr. and Mrs. Cecil A. Van Kleek

21. Nafana; Prestige Cloth; Cotton, Blue Dyes; L. 98"

The *kioyolingo*, or locally woven and dyed country cloth, consisting of narrow three- to four-inch strips sewn together, is a symbol of affluence and social standing among the Nafana, a Senufo-related people of West Central Ghana and the adjacent region of the Cercle de Bondoukou in the Ivory Coast. Although the *kioyolingo* is woven by Nafana men, the dyed cotton threads used by these weavers are prepared by the Dyula, a Muslim Mande culture long resident in this region. The Dyula dominate the dyeing industry throughout this entire zone, and there is not a single urban market town without its complement of Dyula dyers. Nafana weavers either carry their spun

cotton to the Dyula in such urban centers as Bondoukou or Wenchi (Ghana) or await the arrival of the dyers themselves, many of whom circulate from village to village. Dyula dyeing techniques are so decidedly superior in this area that virtually all other cultures have stopped their own dyeing activities. The Dyula use both imported powdered dyes and local indigo-bearing plants *(gara)*, and most admit that although the latter process is more time-consuming, the end result is a more enduring one.
Private collection

22. Hausa, Blanket, Camel Hair and Cotton Thread, L. 103"

In the Bron and Ashanti states of central Ghana, woven and stamped fabrics are also significant items of regalia of all paramount chiefs or Omanhene, subordinate chiefs, village heads, and court officials. Luxurious *kente* and *konin* cloths are worn by virtually all rulers and men of rank and wealth on important state occasions. Yet perhaps one of the most significant fabrics found in these states is an imported textile, the large and elaborately decorated Hausa blanket from northern Nigeria. These blankets were noted by the author in many Bron chieftaincies, where they served not only as prestige pieces purchased in honor of the ancestral stools of the state, but as items of regalia publicly paraded during state ceremonies. Such blankets generally cover the palanquin or *apakan* in which the Omanhene sits when he is carried upon the shoulders of four palanquin-bearers during a festival. Hausa blankets currently in use among the Bron are relatively recent in style, consisting of prominent bands of red and black and large geometric motifs, but the Bron claim that the tradition of using such blankets is in fact very old for blankets like these have long been available to them as a result of the firm trade links that have tied the Bron and Ashanti region of Ghana to Hausaland since the eighteenth century. This example, datable to perhaps the nineteenth century, displays a subdued combination of muted ochres and black.
Private collection

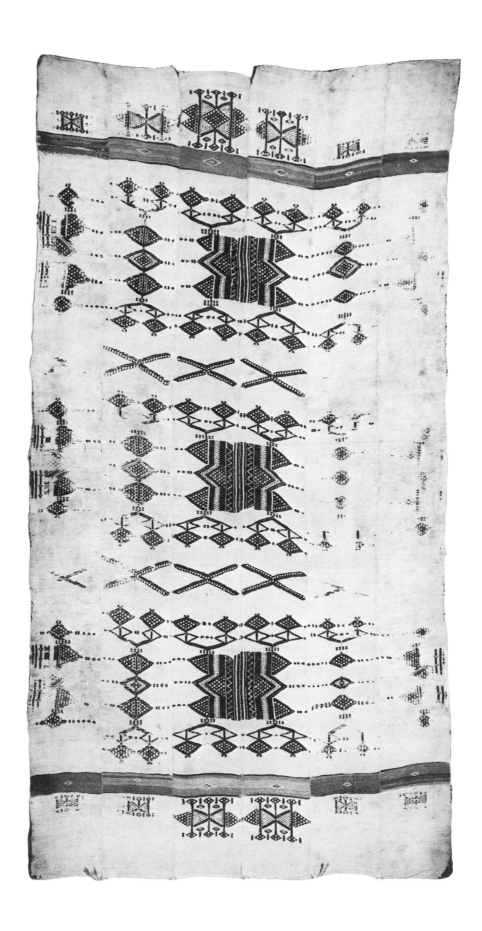

22. Hausa, blanket

23. Degha, Water Container, Terra Cotta, H. 11 ⅞"

While the Muslim Dyula monopolize the art of dyeing in this region, it is the Degha, yet another Gur culture located along the Black Volta River on the very northern fringes of the Bron states of Wenchi and Nsawkaw, who dominate the field of pottery making. Controlling the finest clay beds in central Ghana, Degha women have developed ceramic wares that are clearly superior to all other pottery products for miles about. The excellence of Degha ceramics has been such that they have virtually supplanted all competing traditions. Degha women not only produce a wide variety of pots but are also responsible for the distribution of their products. This they accomplish by either head-carrying their wares to nearby markets or selling their pots to distributors who transport them by trucks to Ashanti and Bron towns for sale in local markets. Among the many varieties of ceramic ware created by the Degha, the most popular and useful type is the *nindo* or water pot. This *nindo,* a late nineteenth-century example with a flat shoulder and basal portion, came from the Bron town of Techiman, where it had been in the family of one of the linguists of the town for nearly two generations.
Private collection

24. Degha, Palm-Wine Container, Terra Cotta, H. 12 ¼"

This double-spouted Degha palm-wine container, a *sugi,* is another late nineteenth-century example of Degha terra cotta craftsmanship. Owned by the Nafana chief of Tambi, in the Cercle de Bondoukou, it was one of several Degha pots which he kept in his compound to store his daily supply of palm wine. The piece is unusual in having a stirrup and double spout, fairly common features of older Degha pots but lacking in contemporary *sugi* vessels. The piece was presented as a token of friendship to Mgono Wolodo, the chief of Tambi at the end of the nineteenth century, by a former chief of Bondakele, an important Degha pottery center twenty miles to the southeast in Ghana.
[Bravmann: 1970, no. 83]
Private collection

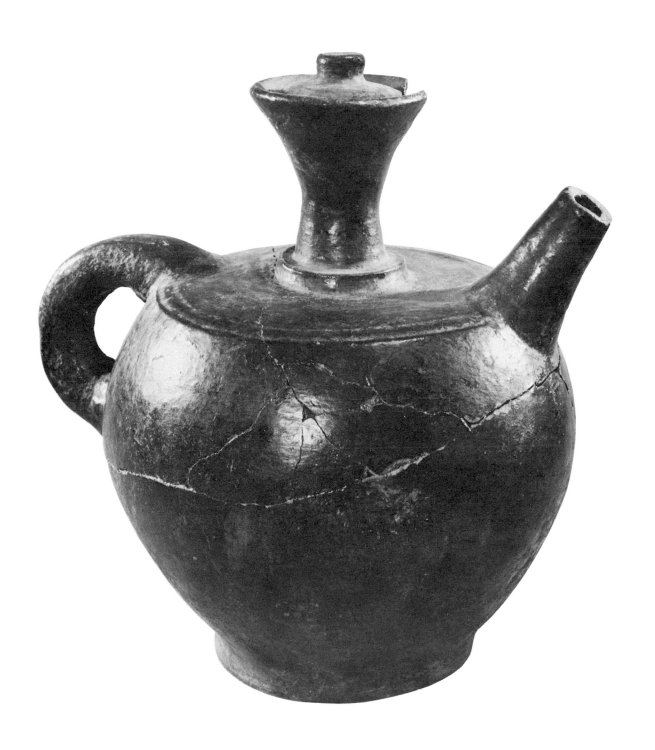

23. Degha, water container

25. Kulango, Heddle Pulley, Wood, H. 4 ⅜″
The art of weaving has always held a high value among the Kulango, and even today, with the increasing availability of imported and less expensive cotton cloths, weaving remains a strikingly vital tradition. Necessary for all narrow horizontal looms, the most prominent loom type in West Africa, is the heddle pulley from which the heddles of the loom are suspended. The Kulango heddle pulley is a personal object, owned and often carved by the weavers and subject to a high degree of individual interpretation: one rarely finds any two alike. Certain Kulango weavers, and carvers who carve virtually nothing but pulleys and whose reputations are assured, carve these objects for all the neighboring groups. This diminutive piece, consisting of a small female head and an upper torso incised with chipped decoration, belonged to a Nafana weaver who had given up his craft as a result of blindness.
Private collection

26. Kulango, Heddle Pulley, Wood, H. 6″
The most important center for the carving of heddle pulleys among the Kulango is the village of Kyende, some fifteen miles north of Bondoukou in the Ivory Coast. Its reputation attracts numerous weavers who come in search of the finest possible loom pulleys. This work, commissioned by a Bron weaver, was refused, not because it was not acceptable artistically, but because the wood upon drying had begun to crack. In view of the stresses upon such an object while it is in use, the weaver commissioned another work in its place. The bush cow head, with a long and delicately curved neck, is one of the most prominent motifs found on Kulango pulleys.
Private collection

27. Kulango, Heddle Pulley, Wood, H. 7 ⅜″
Portable, elaborated sculpturally, and highly desired, Kulango pulleys are found as far afield as the very eastern edge of the Bron region. This example, with a long and simplified neck and a highly abstracted human head, was used in the Bron town of Nkoranza. No longer utilized, it was, however, remembered as an object that had been purchased some forty years before at Nassian, a Kulango town between Bondoukou and Kong.
Private collection

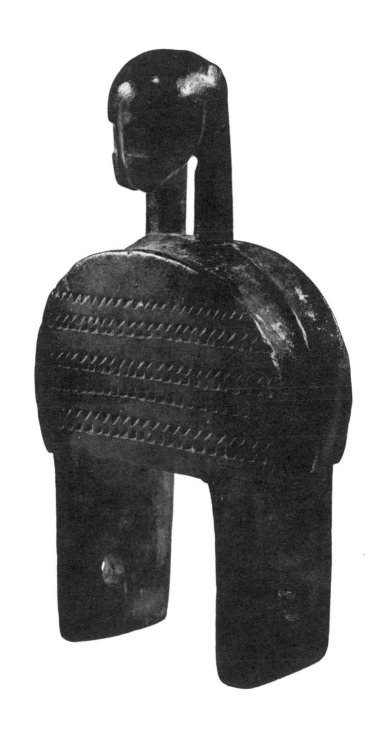

25. Kulango, heddle pulley

28. Dyula; Heddle Pulley; Wood, Glass Bead; H. 6 ⅛″

Carved by a Muslim Dyula weaver in the mixed Dyula/Kulango town of Kanguele, this heddle pulley is stylistically akin to many Kulango examples. It is unusual, however, in that it consists of two human faces sharing a common pair of cow's horns. The chipped decoration on the body of the pulley itself is very reminiscent of Kulango workmanship. Few Dyula weavers do in fact carve their own pulleys, for it is only a rare individual who can compete qualitatively with Kulango masters. The black and white glass trade bead was added to beautify the work.
Private collection

28. Dyula, heddle pulley

29. Mossi, Armlet, Stone, D. 4 ¼″
Like the members of so many other northern
Ghanaian and Upper Voltaic cultures, the Mossi
are found in numerous communities along the
edges of the Ashanti forest. Indeed, virtually
every large town in this area has at least one, and
in most cases several, compounds of Mossi fam-
ilies under the leadership of a Mossi headman.
Among such Mossi immigrants various art forms
have been carried south and retained. This is
especially true of jewelry types such as this finely
worked armlet of black-and-white-veined stone.
As in Mossi country, the armlets are worn only by
women who have attained puberty and serve as
a sign of their important status within the family.
Private collection

30. Lobi, Anklet, Brass, D. 5 ⅛″
Cast brass Lobi objects are found among both
Lobi immigrants and other groups in the area
under discussion. Worn by Lobi women as both
decorations and a sign of status, such anklets are
acquired by Bron and other peoples of this region
merely as additional pieces of jewelry. This work
carries a typical incised broken chevron pattern
on the outer face of the anklet.
Private collection

31. Lobi, Anklet, Brass, D. 5 ⅛″
The variety of brass anklets, armlets, and brace-
lets created by skilled Lobi artisans is bewildering.
Numerous geometric patterns are found on these
delicately cast pieces. This anklet has three
parallel bands of raised dots on the front and
back sides. Only Lobi women wear such pieces,
which are usually given by relatives as gifts when
a daughter reaches puberty. This anklet style was
especially popular among members of the Lobi
quarter in the Bron town of Wenchi.
Private collection

32. Lobi, Bracelet, Brass, D. 3 ⅛″
Today Lobi cast jewelry may be seen throughout
an area extending from the Lobi homeland of
Upper Volta and adjacent portions of the Ivory
Coast and Ghana, to the Ashanti forest. This
bracelet, collected at the Degha-Nafana village
of Jogboi, just north of the Black Volta River on
the motor road to Bole, formed part of the jewelry
collection of an elderly Degha woman. It is not
uncommon to find Lobi jewelry among the Degha
since they themselves have no casting tradition.
Private collection

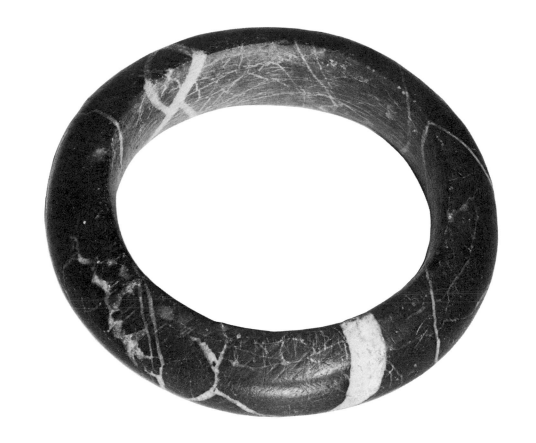

29. Mossi, armlet

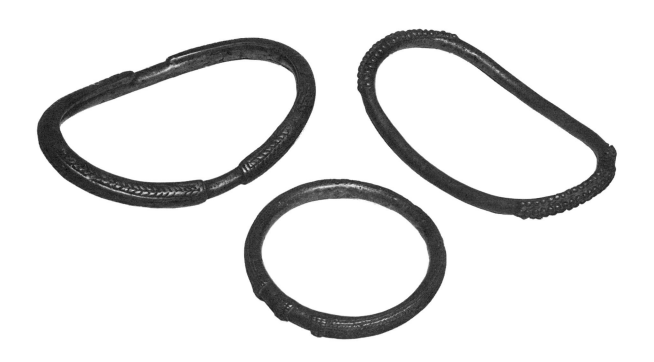

30, 31, Lobi, anklets
32. Lobi, bracelet

33. Lobi, Market Basket, Raffia Cane, H. 5 ¼″
Along with brass jewelry, the most popular Lobi imports in west central Ghana and the Cercle de Bondoukou are small, tightly woven market baskets. Marvelously compact, with a flat, square bottom and upright sides that gradually change from a square to a circular format, they are greatly prized by Bron, Degha, and Kulango women, who find them excellent containers for market produce. In some cases, for example at the Bron town of Nchira, these baskets may even house the important medicines of a local shrine. Two such Lobi baskets are associated with the shrine of Kwaku-Firi, the most powerful spirit shrine among the northern Bron.
Private collection

34. Lobi; Notched Flute; Wood, Leather; L. 16 ½″
This three-note Lobi flute of wood with strips of leather covering virtually the entire instrument is a most impressive example of its type. Although there are no collection data for the piece, it is obviously of Lobi manufacture and very similar to pieces which the author saw being used by Lobi laborers in the region between Wenchi and Bondoukou. The leather covering is an element of beautification and apparently has no esoteric significance.
Gallery Nimba

35. Dagarti; Notched Flute; Wood, String; L. 5 5/16″
Recent northern immigrants to the western Brong/Ahafo region, like the Lobi and Dagarti, often brought with them many of the musical instruments used in their homeland. The mouth bow, or *korinjo*, used by both the Dagarti and the Lobi, is one such instrument. Even more common, however, are the small and beautifully carved flutes used by the Lobi, Gurunsi, and the Dagarti. This three-note Dagarti flute is a personal instrument and is suspended from a leather thong worn about the neck and played for its owner's enjoyment.
Private collection

36. Dagarti, Notched Flute, Wood, L. 2 ⅞″
The range of Dagarti flute forms is apparently quite great, and they may vary in length from one foot to under two inches. Some are long and slender while others, like this one, are bulbous. A good deal of care is lavished upon them by their owners. Oil, generally from the shea nut, is rubbed on the surface of the instrument, and this, added to constant handling, imparts a beautiful glow to the piece.
Private collection

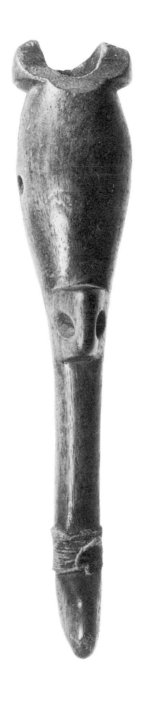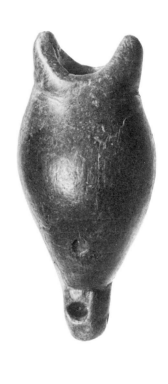

35, 36. Dagarti, two notched flutes

37. Baule, Bottle Opener, Brass, H. 4 ⅜"
Traditionally cast objects of bronze, brass, and gold are well-known features of Baule art. Such pieces were, and continue to be, associated with royalty in this Akan-derived culture. The skill of the caster today, however, is not restricted to "traditional" forms, and this piece is one example of contemporary castings made for a host of new reasons. This elegantly cast "royal portrait" is actually a bottle opener, a Baule object that has become extremely popular among chiefs in the Cercle de Bondoukou. Since many libations are now poured with imported French wine, which is bottled and capped in the Ivory Coast, it seems fitting that at least chiefs and priests should utilize elegant openers. A very similar example, in the possession of the Bron chief of Herebo in the Cercle de Bondoukou, was used only at important state occasions. The stylistic continuity between the royal head depicted here and numerous Baule pendants is remarkable.
Private collection

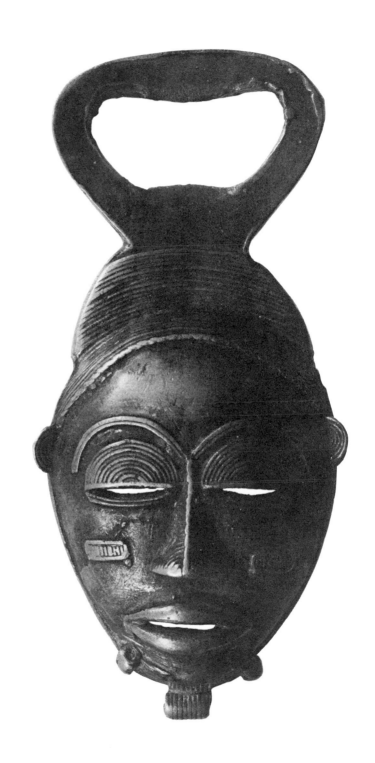

37. Baule, bottle opener

The Cameroonian Grasslands

Beyond the thick forest region of the Federal Republic of Cameroon lie the lush and hilly grasslands. Flanked on the north and west by an impressive chain of mountains, and on the east and south by the valleys of the Sanaga River and its tributaries, the grasslands form an almost continuous plateau region rising in elevation from 1,550 to 4,500 feet. This verdant country of tree-covered hills is only occasionally broken by low-lying plains. The grasslands stretch across both West and East Cameroon. Geographically rich, and with the added benefit of innumerable water sources, the grasslands have been able to support a relatively dense population. Tributaries of the Cross Rivers, the Metcham, the Donga, the Mbam, and the Nun, have not only served to keep communications alive but have facilitated local subsistence economies.

The cultural divisions normally described for the grasslands are those of the Widekum, the Bamileke, and the Tikar. Sometimes the Bamum zone is pointed to as another culture area. There has been, however, considerable confusion and much inconsistency in describing the peoples who inhabit the grasslands, particularly the so-called Tikar cultures. On the basis of recent research by both French and British scholars, it is clear that these old divisions need to be reworked. According to Chilver and Kaberry (1967, p. 125):

Linguistic evidence lends no support to the broad theory of migrations put forward in some British assessment and intelligence reports, in which it was postulated that Tikar or Tikarized peoples from the north-east met and mingled with the so-called "Widekum" peoples of the forested south-west, and were followed by intrusive Chamba, Trans-Donga, and "Munshi" groups.

As they point out, the majority of the people of the grasslands speak Bantoid languages, specifically those belonging to the Ngkom group. The broad term "Tikar" has "neither ethnic nor linguistic connotations: it implies, rather, a claim to the legitimacy of political institutions and to their ultimate derivation from a legendary centre which sanctioned their adoption" (ibid., p. 127).

Sweeping claims made by earlier writers (including those interested in the arts), who have

viewed the Tikar presence in the grasslands as a massive external migration coming from the Chad or the Benue valleys and resulting in the establishment of the major states in the grasslands, are to be seriously questioned. Chilver and Kaberry (ibid., p. 125) clearly indicate that the vast majority of "Tikar" chiefdoms derive from a yet earlier Tikar homeland in the Mbum area of the Nguandere plateau, which lies just north of the grasslands region of East Cameroon, and that these states continue to maintain traditions of origin associating them with Mbum.

This claim varies in expression: in some cases, for example in Nso, Ntem, Ndu, and Ngu, a direct link is asserted with Kimi (Bankim), the senior Tikar chiefdom, or with its coronation site, Rifum. (In East Cameroon, Bamum, Ditam, Bandam, and Bagham among others also have Kimi-derived dynasties.) In others, the claim is more vaguely expressed in terms of origin in "Tikari" or in "Ndobo"—a term sometimes specifically applied to the Tikar area north of Fumban and just south of Banyo, or to the people among whom the Tikar dynasts themselves settled after their legendary exodus from the Mbum area. . . .

The Tikar element in the grasslands, therefore, cannot be viewed as an intrusive, and in origin different, cultural element. These people are historically allied and culturally indistinguishable from other Bantu peoples further east and north. Although most Tikar states claim a similar origin, there are exceptions. These are, as Chilver and Kaberry point out, Mankom, Babungo, and Mbot. Tikar and Tikar-influenced states in the grasslands probably extend back in time two to three hundred years and may well have superseded or absorbed earlier Bantu cultures in this area.

Like the Cercle de Bondoukou and west central Ghana, this is an ethnographically mixed region. Along with the numerous Tikar peoples, there are other cultures which have long been present in the grasslands. The southwestern edge of this area is inhabited by Ekoi-related peoples such as the Banyang, Bayang, Boki, Mbulu, and others referred to collectively as the Widekum. On the northern edge of the grasslands live the Kaka, the Mbembe, and other residual populations who were apparently pushed out of the grasslands themselves during the gradual ascendancy of the

Tikar chiefdoms. The situation in the grasslands is complicated further by the fact that these cultures have interacted, in some cases quite intimately, over at least the last two hundred years.

The influence of the Tikar states is seen everywhere, as far west as the Widekum zone and even among the so-called "splinter" groups like the Kaka and Mbembe. Impressive influences from one culture to another are corroborated by evidence from the arts. The following examples attest to the vitality of trading relations, political alliances, and allegiances; the mobility of artisans; and ultimately the movement and spread of the arts.

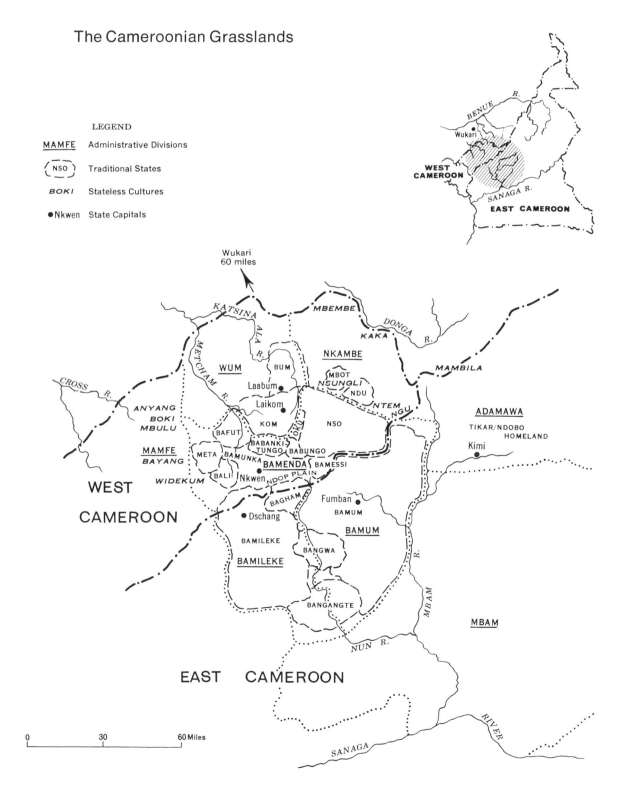

The Cameroonian Grasslands

LEGEND

MAMFE Administrative Divisions

NSO Traditional States

BOKI Stateless Cultures

●Nkwen State Capitals

BENUE R.

Wukari

WEST CAMEROON

SANAGA R.

EAST CAMEROON

Wukari
60 miles

KATSINA

MBEMBE

DONGA R.

KAKA

MAMBILA

ALA R.

METCHAM R.

WUM

BUM

NKAMBE

MBOT

NSUNGLI

NDU

NTEM

NGU

CROSS R.

ANYANG
BOKI
MBULU

Laabum

Laikom

KOM

OKU

NSO

ADAMAWA

TIKAR/NDOBO
HOMELAND

Kimi

BAFUT

MAMFE
BAYANG

META

BAMUNKA

BABANKI
TUNGO

BABUNGO

BAMENDA

BAMESSI

BALI

Nkwen

NDOP PLAIN

WIDEKUM

WEST

CAMEROON

BAGHAM

Dschang

Fumban

BAMUM

BAMILEKE

BANGWA

BAMUM

MBAM R.

BAMILEKE

BANGANGTE

MBAM

EAST CAMEROON

NUN R.

SANAGA

RIVER

0 30 60 Miles

38. Widekum, Face Mask, Wood, H. 18 ½″
Descendants of the Ekoi who migrated from the Cross Rivers into the Mamfe Division of West Cameroon during the eighteenth and nineteenth centuries are collectively referred to as Widekum. Although maintaining traditions that clearly indicate their Ekoi origins, they have adopted numerous Tikar culture traits. This mask, collected by Paul Gebauer at Mameta, is an excellent example of the fusion of Ekoi and Tikar elements. Stylistically the work relates strongly to Ekoi helmet mask types of the Ekkpe cult, but functionally it operates in a manner that is purely Tikar. Such a mask is associated with the policing of markets and is carried by members of the Kwifon, a society that seeks to regulate trade procedures. These masqueraders carry out rituals on primary market days; they collect fines, adjudicate disputes, and punish thieves and cheats when necessary. Although Widekum masks are usually overlaid with animal skin, as among the Ekoi, there is no such overlay in this example.
Mr. and Mrs. Paul Gebauer

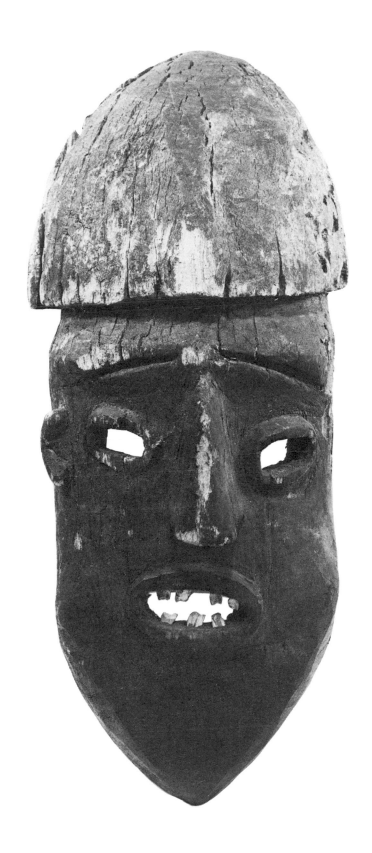

38. Widekum, face mask

39. Widekum, Mask, Wood, H. 14 ½"
This example also relates visually to what is generally referred to as an Ekoi Ekkpe cult mask. Its origins, however, are probably not the Cross Rivers region but the forest country and adjacent grassland portion of West Cameroon dominated by the Widekum. It may, like the preceding example, also be associated with the Kwifon regulatory society, which generally serves as a counterpoise to check and balance the power and authority of the chiefs of state. This piece, like the other, lacks an animal skin surface.
Gallery Nimba

40. Widekum; Helmet Mask; Wood, Animal Skin; H. 19 ⅛"
This Widekum mask includes a covering of animal hide stretched tightly over the wooden surface. The skin is glued and pegged in place. The mask retains the open mouth, bared teeth, and wide-eyed gaze that are typical features of the Ekoi skin-covered masks from which it is derived.
[Bravmann: 1970, no. 125]
Seattle Art Museum, 65.AF16.17

41. Kom; Face Mask; Wood, White Clay; H. 15"
The political and trading relationships of the state of Kom with many Tikar chiefdoms of the grasslands are well known. Ideally located with respect to the trade routes from the Benue River, and in the very heart of the grassland itself, Kom was a logical distribution point for a variety of trade items and luxury goods. Trade apparently extended to ritual objects such as this Kom face mask, probably carved for the Kwifon and found in Mbembe country at the very northwestern corner of West Cameroon. Typical of the Kom carving tradition, this triangular and highly simplified face mask was beautified by the application of a white clay paint to the area of the mouth, the hairline, the outer ear, and the rims of the eyes. In Mbembe territory it was used primarily as a hunting society mask.
Portland Art Museum, 70.10.19

41. Kom, face mask

42. Bamum; Mask; Wood, White Clay; H. 19 ½″
The Kwifon society among the Bamum, as in all
grassland states, is the primary patron of masks,
the major social control organization. Its masks
perform at all important political festivals, at
the funerals of chiefs, for the promotion of crop
fertility and successful hunts, and to regulate
marketing and trading procedures. Elders of the
Kwifon in all Tikar states often give such masks to
neighboring Kwifon organizations as political or
prestige gifts. While the majority of Kwifon masks
are of a crest variety and are worn on top of the
head, this example is a casque mask covering the
entire head of the dancer. The pouchy cheeks
and open-mouthed grin typical of Kwifon masks
are clearly evident here.
Gallery Nimba

43. Bamum, Helmet Crest, Wood, H. 16″
According to Gebauer, who collected this Kwifon
crest piece from the Fon of Bum, the mask was
probably acquired by the paramount through the
royal trade network that flourished between the
states of Bum and Bamum. Gebauer believes that
it was most probably carved among the Bamum
because of several stylistic features: the very
prominent pouchy cheeks, the strong emphasis
upon the ears, and the elaborate openwork head-
gear consisting of several stylized lizards. This
reptile, sacred to the Bamum and to other groups
of Tikar origin, is the most common feature of
Bamum masks. Why this mask was traded is not
known, but it may well have formed part of a
larger exchange of royal gifts. The ties between
the states of Bum and Bamum date back to the
nineteenth century, and there has been constant
interaction between these two states since that
time. Somewhat smaller than most Bamum crests,
the work is a masterpiece of the Bamum carver's
art.
Portland Art Museum, 70.10.14

43. Bamum, helmet crest

44. Bamum, Face Mask, Brass, H. 14 ½"
Under the sponsorship of Fon Njoya, the tradition
of casting masks of brass was begun at the turn
of the century. Such pieces quickly gained pop-
ularity throughout the Cameroon grasslands and
were soon used within a variety of masquerade
contexts by the Bamum and other groups in the
interior. Today brass masks are a sign of prestige,
and Tikar chiefs generally attempt to convert as
many wooden masks as possible into brass. The
heart of the brass-casting tradition is still the
capital town of Fumban, the center of Bamum
culture. This example, almost identical to brass
masks presently used to greet political officials of
the Cameroon government at Fumban, was cast
by the Muslim artist Ardu Habdo. Although
originally from Fumban, he was working in the
1950s at the town of Nkwen in West Cameroon.
The object is typical of the brass face mask type,
consisting of the face of a ruler surmounted by a
combined motif of two sacred crocodiles and a
spider. The frequent appearance of this insect on
such works is due to the fact that it is used
throughout the grasslands for divination purposes.
That the mask is a royal image is clear because the
beard is decorated by a strand of beads.
Henry Art Gallery

44. Bamum, face mask

45. Bamum, Stool, Wood, H. 15″

In the Cameroon grasslands chiefdoms such as Bamum, stools are one of the primary items of regalia associated with royal prerogative. Their intimate ties with chieftancy has made them an especially appropriate exchange item among such states, and this has been particularly true of those chieftaincies whose dynasties claim either Tikar or Ndobo origins. Trade contacts, military alliances, diplomatic relationships, and the exchanging of gifts by rulers has dominated the interactions between the states of Bamum and Kom, and this stool is an example of the flow of gifts between them. Although carved in Bamum, it was collected at the Kom capital of Laikom where it had once formed part of the state regalia. The stool, supported by a cylindrical openwork base, carries two very prominent Tikar symbols: the earth spider (considered to be the mediator between man and the ancestral world), used for divining the future and symbolic of wisdom and cunning; and the vulva, with its associations of human fertility and reflections of the continuity of the state.

Mr. and Mrs. Paul Gebauer

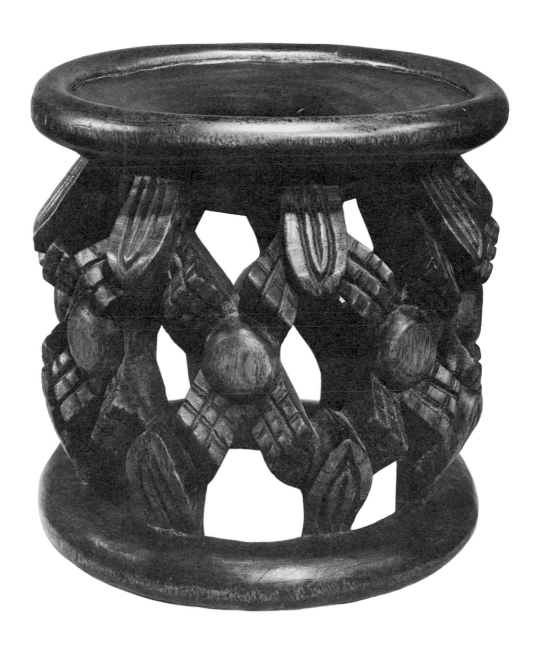

45. Bamum, stool

46. Bamum, Royal Stool, Wood, D. 16″
Collected in 1938 among the Bamunka of the Ndop plain, this royal stool was probably carved in the chiefdom of Bamum. Paul Gebauer favors Bamum as its point of origin on the basis of the motifs between the seat and the base of the stool: carved in an openwork fashion, these consist of three parallel rows of eight royal ancestor heads separated by two bands of stylized pythons. The latter, a sacred and totemic animal among the Bamum, is a favorite ancillary motif used by Bamum craftsmen.
Portland Art Museum, 70.10.9

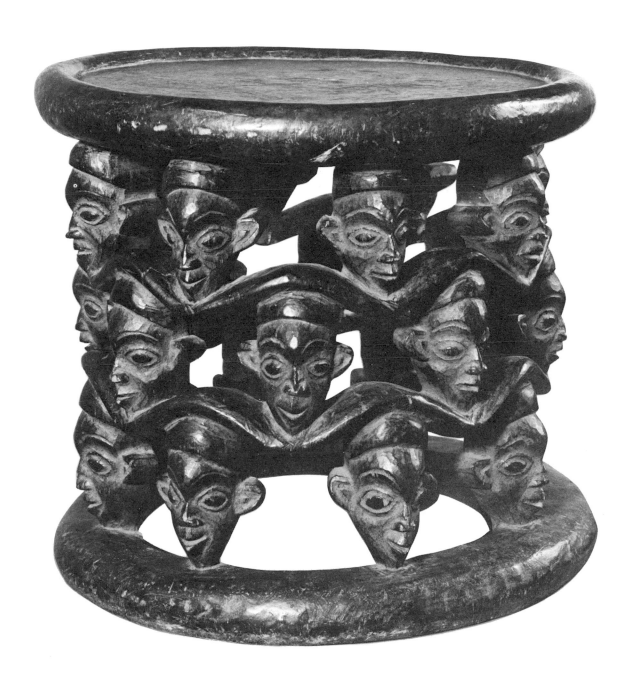

46. Bamum, royal stool

47. Babanki-Tungo; Stool; Wood, Oil; H. 15 ¾″
Among Babanki-Tungo leaders, the baboon is
considered to be a totemic animal and, as such,
is protected and revered. In addition, the baboon
is a symbol of prestige, and its image appears on
a wide variety of art forms, including royal stools.
This stool, consisting of a baboon figure support-
ing the seat, was carved in 1935 and expresses yet
another dynamic dimension found in African art.
Although absolutely traditional in style and icono-
graphy, the work is one of many examples of this
royal object type carved for completely non-
traditional purposes. Stools like this one were
often fashioned for French and British colonial
officials, who used them as lamp tables. Today
the Babanki-Tungo baboon stools are often found
in the homes of Cameroon government officials
where they apparently serve as decorative objects.
Mr. and Mrs. Paul Gebauer

**48. Babungo; Iron Bell; Iron, Wood, Pitch;
H. 18 ¼″**
Among the Babungo and other Tikar-derived
states, royal bells with either one or two clappers
are used as symbols of authority. Single-clapper
bells, with elegantly carved handles in the form
of a chief's head and neck, were used by the most
prominent royal wives to awaken their chiefs, to
announce messengers, and to signal the arrival
of honored guests. Bells were also a basic element
in the gift exchanges between rulers. Entrusted to
royal messengers, they were carried in special
raffia bags to the courts of allies and friends. The
circulation of bells appears to have been as im-
portant as the distribution of brass pipes, dyed
cloths, a wide variety of jewelry, and elegantly
carved drinking horns. According to Gebauer, this
piece was carved in Babungo country and was re-
tained by the Fon of Babungo because of its
exceptional beauty.
Mr. and Mrs. Paul Gebauer

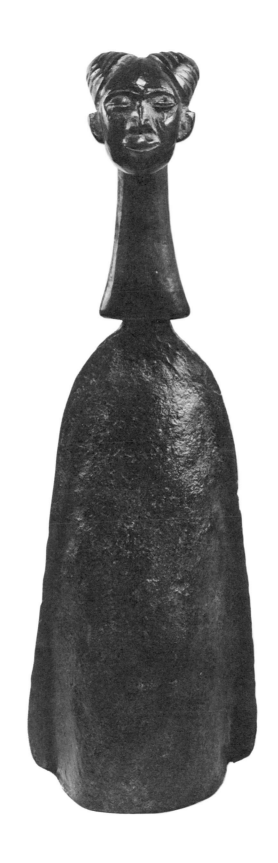

48. Babungo, iron bell

49. Bamum; Neck Ring; Brass, Bronze; D. 10″
Neck rings were cast and forged by the Bamum at the capital of Fumban, where they served as royal insignia for the Fon and a host of court officials directly under his control. Although the production of neck rings was clearly restricted to Fumban, the objects were given by the Fon of Bamum to other rulers to cement alliances and confirm friendships. Fon Njoya, who is still remembered for his munificence, distributed such rings throughout his reign, and those in the state treasuries of Kom and Bafut are examples of his generosity. The two neck rings in the royal store-houses of Kom and Bafut are of the same type as this example, consisting of thirty-five miniature cast buffalo heads. This neck ring was collected at Fumban in 1936.
Henry Art Gallery

50. Bamum, Neck Ring, Brass, D. 11 ½″
This royal neck ring, which includes thirteen cast heads of Tikar chiefs, is a masterpiece of Bamum brasswork. Individually cast, the small heads (each approximately 2¼″ in height) were strung onto the neck ring and then soldered into place. The association of such objects with royalty has just been noted, but they are also used in non-traditional political and state occasions. Gebauer relates that a neck ring of this type was given by Fon Njoya to the German colonial governor Jasko von Puttkamer in 1904 as a token of respect and friendship, and even today Cameroonian govern-mental officials, such as Al Hajj Ahmadu Ahidjo, the president of the Federal Republic of Cam-eroon, wears a similar neck ring when visiting Fumban and the villages of Bamum.
Mr. and Mrs. Paul Gebauer

51. Anyang/Widekum; Trumpet; Ivory, Brass, Silver; L. 21 ¼″
Among the cultures comprising the peoples generally referred to in the ethnographic literature as Widekum are the Anyang of West Cameroon, who inhabit the very western edge of the Bamenda plateau. Like all other "Widekum" cultures, the Anyang have retained many of their Ekoi char-acteristics while adopting numerous Tikar or Ndobo cultural and material traits. This splendid side-blown ivory trumpet, with a brass inlaid mouthpiece and a silver rim worked around the perimeter of the mouth of the horn, seems to be an example of the diffusion of the Tikar ivory trumpet, but it demonstrates the elaboration of this type by non-Tikar stylistic elements. Although the relief head opposite the mouthpiece does carry some Tikar features (for example, the open-mouthed grin and clearly rimmed eyes and ears), the long flowing beard, consisting of tendril motifs, and the spiky headdress are decidedly non-Tikar in their rendering. The small bird nestled in the coiffure of the head is also unlike anything found among Tikar groups.
Seattle Art Museum, Gift of Nasli and Alice Heeramaneck, 68.AF10.19

51. Anyang/Widekum, trumpet

52. Bamum; Royal Cloth; Cotton, Indigo; 64″ x 121″

Dyed blue cloth has long been a trade item in the interior of Cameroon. Certain imported types, such as Jukun, stenciled, and tie-dyed varieties, have been a major exchange good between the Benue River Valley and the grassland states. According to Chilver and Kaberry (1967, p. 134), the state of Kom in the nineteenth century "acted as middleman for the distribution of Jukun cloth, obtained from Bum, trading it to Nkwen and some of the villages in the Ndop Plain, who were in touch with the markets of Bagham and Bamendjinda. . . . " Despite the many imported cloths coming from the Benue, which were carried by Hausa traders, local dyeing and stenciling traditions apparently flourished. The major grassland centers for the dyeing of royal cloth were Laabum (Bum), Laikom (Kom), and the Bamum capital of Fumban. The latter two are still important towns for the production of this art form. This cloth, datable to the twentieth century and from the town of Bamum, was acquired by Gebauer at the Fumban Museum in 1936.
Portland Art Museum, 70.10.81

53. Bum; Royal Cloth; Cotton, Indigo; 216″ x 72″

Tie-dyed and stenciled cloths are found throughout the length and breadth of the Cameroon grasslands. As prestige items they are associated with the courts of all Fons and in certain instances are also utilized by the heads of important villages. Such cloths were, and still are, important gifts to be distributed by Fons to subordinate chiefs within their states. These large cloths, consisting of numerous narrow strips of cotton, three to four inches wide, sewn together, serve as scenic backdrops for important occasions of state held at royal palaces and during certain ritual festivities carried out by the Kwifon or regulatory society. Tacked to the inner face of the fences surrounding the royal compound or placed on the walls of individual houses, these hangings serve to beautify the festival enclosure. They are, however, not merely decorative, for the design patterns on these cloths are a veritable palace plan, indicating the dwelling huts, storage houses, kitchens, shrine rooms, and courtyards of the royal compound. In some cases the cloths are also used in the elaborate burial ceremonies lavished upon a Fon.
Mr. and Mrs. Paul Gebauer

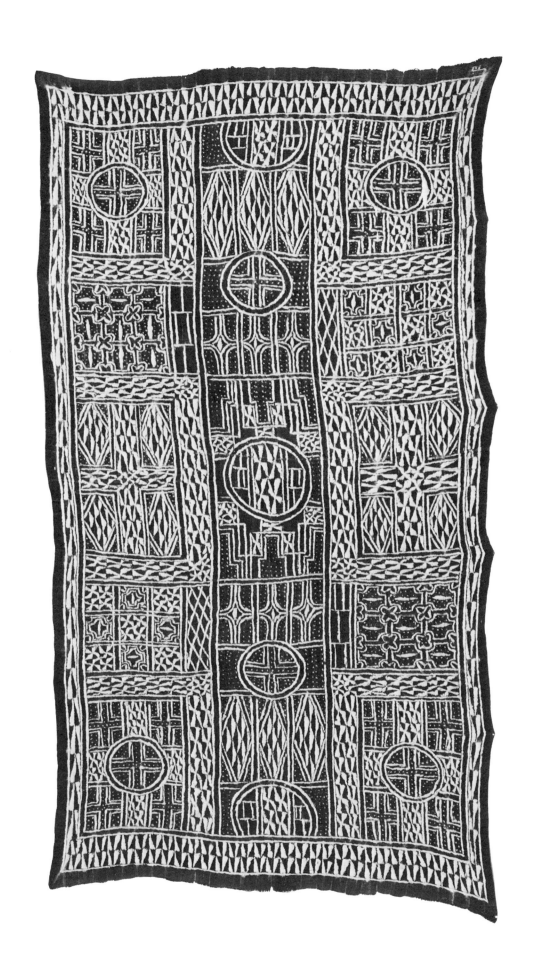

53. Bum, royal cloth

54. Kom, Royal Gown; Cotton Cloth, Embroidery; W. 78"

This black and orange royal Kom gown, with red, black, yellow, and white embroidery work about the neck, is merely one example of the sumptuous garments worn by the Fons of the grasslands states. Numerous political and ritual obligations entitle these men to such fineries, and their rich wardrobes testify to their elevated rank and status. As items of prestige, gowns have often been given as tokens of friendship or as part of the material settlement in a dispute between royal families or states. The variety of colored cotton pieces and threads used is dazzling, and no two gowns are alike. Indeed, a high degree of originality in the choice of colors and embroidered designs seems to be a necessary feature in the creation of such works.
Mr. and Mrs. Paul Gebauer

55. Kom; Royal Cap; Dyed Fibers, Feathers; D. 9 ½"

"Competitive accumulation and distribution of wealth" was a primary feature of the various states in the Cameroon grasslands. Chiefs distributed objects of regalia to important individuals and favorite clients while also engaging "on their own behalf in gift-exchanges with their peers" (Chilver: 1961, p. 241). The constant circulation of royal artifacts not only operated at the very heart of the state economy but served also to cement and renew shifting allegiances. Royal caps, such as this example from the Kom capital of Laikom, were a particularly valued commodity circulated by rulers. Kom caps, according to Gebauer, were distributed as far afield as the Mamfe Division in West Cameroon and the Bamileke country. This piece combines the striking use of red, black, yellow, blue, green, and white cotton with feathers.
Mr. and Mrs. Paul Gebauer

56. Nsungli, Royal Cap, Grass Fibers, D. 8 ½"

A high degree of artistry is displayed in this tightly knit royal cap from the Nsungli of the chiefdom of Mbot, located in the Nkambe Division. It is unusual because the grass fibers have been left their natural color. Royal caps are rarely treated in such a restrained fashion but generally include a variety of colors and motifs.
Mr. and Mrs. Paul Gebauer

57. Nsungli; Royal Cap; Grass Fibers, Dyes; D. 8 ½"

Although knit by Nsungli craftsmen, this cap, like the previous example, was acquired at the Kom capital of Laikom. Typical of the royal headgear of Tikar chiefs, it consists of bold geometric designs defined by a variety of colors: oranges, yellow, red, black, and white. The concentric circles of color on the crown of the cap heighten the striking effect of the total work.
Mr. and Mrs. Paul Gebauer

58. Nsungli; Royal Cap; Grass Fibers, Dyes; D. 9"

Collected among the Widekum of West Cameroon, this is yet another example of the superior knitted caps produced by Nsungli men. Although using a variety of dyed color fibers, this cap is considerably more restrained than the previous example.
Mr. and Mrs. Paul Gebauer

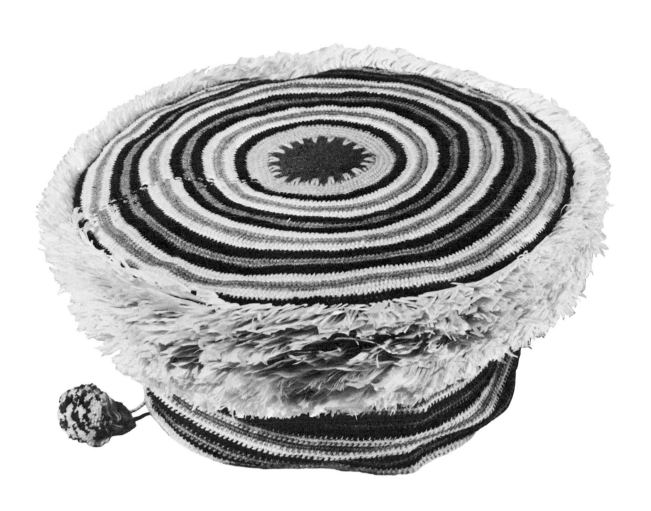

55. Kom, royal cap

59. Tungo, Drinking Horn, Buffalo Horn, L. 8″
Elegantly carved drinking horns form part of the ensemble of personal objects owned by all paramount chiefs in the grasslands of Cameroon. Highly prized, they served as gifts of friendship and were circulated widely among Tikar royal families. The motifs carved on the surface of these horns clearly delimit their association with royalty. This horn includes a high-relief figure of a Tikar chief on the inner surface, with three retainers appearing on the sides and outer face. Totemic symbols of the lizard and frog flank the retainers. Carved in the Tungo region of Bamenda Province, it was collected by Paul Gebauer in the Nkambe area some sixty miles to the north.
Henry Art Gallery

60. Bamessi; Tobacco Pipe; Terra Cotta, Wood; L. 31″
The art of making tobacco pipes apparently reached its highest point among the Bamessi of the Western Grasslands. Prized for their beauty and their obvious utility, Bamessi pipes were eagerly sought by virtually all Tikar peoples. Gebauer has mentioned that Bamessi pipes could be found all over the interior of Cameroon in the 1930s and 1940s, and this example was collected in a coastal market about two hundred miles from the Bamessi area. It is possible that the piece was carried such a distance by a Bamessi laboror, for many moved to the coast during this time in search of work at one of the many French plantations. The heavily designed bowl and shank consist of cowrie shell and lozenge patterns symbolic of material wealth, heightened social identity, and human fertility. The knobbed branch for the stem of the pipe was apparently used to contrast the stem with the minimally sculptured form of the pipe bowl itself.
Henry Art Gallery

61. Bangangte; Tobacco Pipe; Terra Cotta, Wood; L. 22″
This Bangangte pipe, depicting a seated royal personage wearing a large cascading cap, is yet another example of this personal object type. Paul Gebauer collected it in the Bangwa region in 1934.
Henry Art Gallery

62. Bagham, Tobacco Pipe Bowl, Brass, H. 6 ⅝″
The art of casting brass pipe bowls developed to a very high point in areas outside of Bamessi as well as within it. This pipe is from Bagham country. Intensive trade relations between the Bagham and the Bamileke states to the south resulted in the presence of many cast Bagham pipe bowls throughout the Bamileke zone. This pipe, consisting of the head of an elephant and stylized tusks which allow the piece to rest easily on the ground while it is being smoked, is typical of Bagham workmanship. Bagham pipes do not as a rule carry secondary surface decoration, the impact of the piece being conveyed by the central motif.
Seattle Art Museum, 68AF6.6

63. Bamessi, Palm-Oil Bowl, Terra Cotta, D. 8″
Although pottery traditions occur among many grasslands cultures, one of the most prominent centers of production is the Bamessi chiefdom of Ndop Plain, which occupies an area comprising some of the richest clay deposits in interior Cameroon. Bamessi women have developed a variety of wares whose quality and popularity are clearly demonstrated by their wide distribution and acceptance. Bamessi ceramics are found in all Tikar- or Ndobo-derived states. They have been seen as far north as the Donga River region among the Kaka and Ntem, to the west in Widekum villages of Mamfe Division, and to the south and east in the chiefdoms of the Bamileke and Bamum. One of the most beautiful Bamessi ceramic types is the small palm-oil dish, consisting of a shallow bowl portion, a handle, a spout or a decorative motif in lieu of the spout, and a footed base or stand.
Mr. and Mrs. Paul Gebauer

59. Tungo, drinking horn

64. Bamessi, Palm-Oil Bowl, Terra Cotta, D. 8 ¼″
Bamessi ceramics are not only considered to be among the finest produced by Cameroon peoples, but they are easily obtained. The central location of the chiefdom and its markets has given Bamessi potters a decided advantage in the distribution of their wares. Lying at very nexus of the major trade routes connecting the numerous Tikar and non-Tikar chiefdoms of the grasslands, Bamessi is within easy access of traders who flock to her markets to obtain these excellent and beautiful products. Recognizing the large export trade, and catering to it, Bamessi women give many of their wares only a light firing so that they may be transported long distances (generally head-carried in large woven baskets or carted away on litters) without cracking and chipping. Such pots, however, are invariably fired a second time once they have been delivered to their destination. Bamessi women create a number of pottery types, ranging from three-foot-high water containers to delicate and diminutive palm-oil bowls, but all varieties are avidly sought and traded. This palm-oil bowl, with a handle and spout but no stand, is a rather restrained and simplified version of its type.
Mr. and Mrs. Paul Gebauer

65. Bamessi, Palm-Oil Bowl, Terra Cotta, D. 8″
The wide distribution of Bamessi pottery is due not only to a well-developed trade network, but also to the fact that Bamessi royal women gave many gifts of ceramic ware to royal women of other chiefdoms. According to Gebauer, the head wife of Fon Njoya, who prized Bamessi ware above all others, had some fifty examples in her royal kitchen. This highly developed palm-oil bowl, with an elaborate, geometrically conceived base and a high-relief design gracing the outer wall of the bowl, was collected at Fumban in Bamum country. A delicate boss of clay has replaced the spout and echoes the slender handle. Gebauer suggests that the palm-oil variety that no longer has a functional spout is possibly the latest development within this type, but further evidence is needed before such a developmental sequence can be determined with real certainty.
Mr. and Mrs. Paul Gebauer

65. Bamessi, palm-oil bowl

66. Kwadja, Money Piece, Iron, D. 20 ⅜″
The Kwadja of the northern sector of the Nkambe
Division of West Cameroon are a blacksmithing
group of cardinal importance. They produce a
wide array of iron products and in the past were
responsible for the manufacture of iron plates,
which were used throughout the western grass-
lands of Cameroon as a medium of exchange.
Such Kwadja plates, according to Gebauer, were
commonly found in the 1930s and 1940s among
all Kaka peoples of the Upper Donga Valley and
were also utilized by the Mambila, who resided on
the plateau just north of the Donga River. The
Mambila, anxious to obtain this valuable cur-
rency, willingly traded salt, beads, and imported
tobacco (the last coming from Nigeria via the
Hausa routes originating along the Benue River).
Despite the increasing popularity and availability
of British currency in the Nkambe district in the
1950s, the Kwadja plates were still utilized and
highly prized. Gebauer relates that during this
period the headmaster of the Baptist Mission
School at Mbem was able to purchase three times
as much food for his students in local markets by
using the plates rather than British currency.
Mr. and Mrs. Paul Gebauer

66. Kwadja, money piece

67. Babanki-Kijem; Royal Guardian Figure; Wood, Charcoal; H. 33"

This monumental guardian figure carved by Vughar, a prominent Babanki carver, is an excellent example of yet another kind of mobility found within the art of Black Africa. Although fashioned to be used within a traditional context, it was not acceptable to Babanki consumers on stylistic grounds and was therefore purchased in 1950 by the Cameroonian Baptist Mission School at Nkwen, West Cameroon. At the school it was hoped that the figure would serve as a decorative item gracing the entryway to the school yard. It was bolted to the cement wall and remained there until 1965, when it was removed because students at the Mission School had begun to use it for propitiation purposes. According to Gebauer, the schoolboys became accustomed to offering cigarettes and bottles of beer to the figure before examination periods, and the schoolmasters, appalled by such actions, removed the piece. The work is in pure Babanki style and represents a typical guardian figure wearing a royal cap. The only unusual feature is the European-style chair on which the royal male is seated. Offerings by the students were placed between the spread legs of the figure.
Henry Art Gallery

67. Babanki-Kijem, royal guardian figure

68. Babanki-Tungo; Altar Post; Wood, Charcoal; H. 22″
Carved by Tita Taunto, a Babanki-Tungo carver in the early 1950s, this object has had a fascinating history. Originally fashioned as one of several altar posts for the Baptist chapel at Mbem in Kaka country, the post and several altar rails were removed from Mbem in about 1960 and taken sixty miles south to the town of Nkwen in Bamenda Province, where a new and more impressive Baptist church had just been completed. The altar rail sections, consisting of typical "nude" male and female ancestor figures, were incorporated as panels of the large wooden doors of the chapel, while the post was to be used for the new altar. A year later, after considerable discussion, the elders of the church decided not to accept the altar post because of its obviously non-Christian imagery and associations and, in addition, had the genitalia removed from the figures on the chapel doors. The post, consisting of six royal ancestors, four portrait heads, and two totemic birds carved in high relief, is topped by a fully carved spider—an insect used throughout the grasslands for divination and communication purposes.
Mr. and Mrs. Paul Gebauer

68. Babanki-Tungo, altar post

69. Bamum, Crucifix, Brass, H. 8 ⅝″
Salefu Bainkom, a master caster, was among the many Bamum artisans who left French Cameroon in 1934 when its king, Fon Njoya, was exiled by the French. Seeking political asylum in British Cameroon, he settled at Bafreng, in Bamenda Province, where he continued to carry on his work. While at Bafreng he began casting crucifixes for a Dutch priest in charge of the Roman Catholic Church who commissioned these works for supporters of the mission in Europe. Although such pieces were initially created for export purposes, they gained local popularity and were gradually adopted by many cultures, as far afield as the Bamum region and the Mamfe Division, as protective figures. Gebauer suggests that this style is based upon a Tyrolean wooden crucifix type, but Salefu interpreted the figure liberally. The physical features of Christ's face are those of the Fulani, a semisedentary population that migrated into the northern grasslands of Cameroon in the nineteenth century and raided Bamum country for slaves. They were, and still are, regarded by the Bamum as archenemies, and thus with considerable suspicion. The crown of thorns is retained but is treated as a tufted cap, the royal headgear worn by all chiefs in the grasslands.
Mr. and Mrs. Paul Gebauer

70. Bamum, Wall Plaque, Wood, H. 45″
Shallow relief plaques, a feature of all royal compounds in interior Cameroon, are found upon the lintels of the entryway to a chief's compound and as decorative borders surrounding the doorways of individual sleeping and storage rooms. At Fumban, the roof planks of the city gate were delicately incised with the heads of chiefs and ancestors. Indeed, it appears that relief sculpture reached its highest peak at Fumban, where the royal family patronized and supported this art form. Although such plaques usually include images of rulers and ancestors, the treatment is generalized and idealized and not conceived as portraiture. This plaque is unusual, then, for it includes three detailed and specific renderings of the great Muslim Bamum ruler Njoya, wearing a turban and gown. Carved by a Bamum artisan, who was himself a Muslim, the work is one dramatic refutation of the axiom that Islam has had an invariably destructive effect upon traditional figurative art. Commissioned by Sultan Njoya and executed by a Muslim follower, it was one of the many plaques that would have been used to grace the inner walls of the ruler's compound.
Mr. and Mrs. Paul Gebauer

69. Bamum, crucifix

Bibliography

Arhin, Kwame
 1967 "The Structure of Greater Ashanti," *Journal of African History,* Vol. 8, No. 1, pp. 65-85.

Bascom, William
 1969 "Creativity and Style in African Art," in *Tradition and Creativity in Tribal Art,* edited by Daniel Biebuyck, pp. 98-119. University of California Press, Berkeley and Los Angeles.

Bascom, William R., and Paul Gebauer
 1953 *Handbook of West African Art.* Bruce Publishing Co., Milwaukee.

Biebuyck, Daniel P., ed.
 1969 *Tradition and Creativity in Tribal Art.* University of California Press, Berkeley and Los Angeles.

Bravmann, René A.
 1970 *West African Sculpture.* Index of Art in the Pacific Northwest, No. 1. University of Washington Press, Seattle.
 1972 "The Diffusion of Ashanti Political Art," in *African Art and Leadership,* edited by Douglas Fraser and Herbert M. Cole, pp. 153-71. University of Wisconsin Press, Madison.

Chilver, E. M.
 1961 "Nineteenth Century Trade in the Bamenda Grassfields, Southern Cameroons," *Afrika und Übersee,* Vol. 45, No. 4, pp. 233-57.

Chilver, E. M., and P. M. Kaberry
 1967 "The Kingdom of Kom in West Cameroon," in *West African Kingdoms in the Nineteenth Century,* edited by Daryll Forde and P. M. Kaberry, pp. 123-51. Oxford University Press, London.

Fagg, William
 1965 *Tribes and Forms in African Art.* Tudor Publishing Co., New York.
 1966 *African Tribal Sculptures: 1, the Niger Basin.* Tudor Publishing Co., New York.
 1970 *African Sculpture.* International Exhibitions Foundation, Washington, D.C.

Fraser, Douglas, and Herbert M. Cole, eds.
 1972 *African Art and Leadership.* University of Wisconsin Press, Madison.

Gebauer, Paul
 1964 *Spider Divination in the Cameroons.* Milwaukee Museum
 Publications in Anthropology 10, Milwaukee.
 1971 "Art of Cameroon," *African Arts,* Vol. 4, No. 2 (Winter),
 pp. 24-35, 80.
 1971 "Architecture of Cameroon," *African Arts,* Vol. 5, No.
 1 (Autumn), pp. 40-49.
 1972 "Cameroon Tobacco Pipes," *African Arts,* Vol. 5, No. 2
 (Winter), pp. 28-35.
Goody, John R.
 1954 "The Ethnography of the Northern Territories of the
 Gold Coast, West of the White Volta," Colonial Office
 Mimeograph, London.
 1964 "The Mande and the Akan Hinterland," in *The Historian
 in Tropical Africa,* edited by Jan Vansina, Raymond
 Mauny, and L. V. Thomas, pp. 193-218. Oxford University
 Press, London.
Goody, John R., and Kwame Arhin, eds.
 1965 *Ashanti and the Northwest.* Institute of African Studies,
 Legon.
Jeffreys, M. D. W.
 1950 "The Bamum Coronation Ceremony as Described by
 King Njoya," *Africa,* Vol. 20, No. 1, pp. 38-55.
 1952 "Some Notes on the Bikom Blacksmiths," *Man,* Vol. 52,
 No. 2 (April), pp. 49-51.
Kyerematen, A. A. Y.
 1961 *Regalia for an Ashanti Durbar.* Guide to Durbar in
 Honour of Her Majesty Queen Elizabeth II. Kumasi,
 Ghana.
 1964 *Panoply of Ghana.* Longmans, Green and Co., London.
Labouret, Henri
 1931 *Les Tribus du Rameau Lobi.* Institut d'Ethnologie, Paris.
Lecoq, Raymond
 1953 *Les Bamileke.* Présence Africaine, Paris.
McLeod, M. D.
 1971 "Goldweights of Asante," *African Arts,* Vol. 5, No. 1
 (Autumn), pp. 8-15.
Ottenberg, Simon
 1971 *Anthropology and Aesthetics,* an open lecture delivered
 at the University of Ghana. Ghana Universities Press,
 Accra.
Portland Art Museum
 1968 *A Guide to Cameroon Art from the Collection of Paul
 and Clara Gebauer.* Portland, Ore.

Rattray, R. S.

1927 *Religion and Art in Ashanti.* Clarendon Press, Oxford.

1929 *Ashanti Law and Constitution.* Oxford University Press, London.

Rudy, Suzanne

1972 "Royal Sculpture in the Cameroons Grasslands," in *African Art and Leadership,* edited by D. Fraser and H. M. Cole, pp. 123-35. University of Wisconsin Press, Madison.

Sieber, Roy

1966 "Some Comments on Art and History in Africa," *Ghana Notes and Queries,* No. 8, pp. 6-9.

1967 "African Art and Culture History," in *Reconstructing African Culture History,* edited by Creighton Gabel and Norman Bennet, pp. 117-37. University Press, Boston.

1972 "Kwahu Terracottas, Oral Traditions, and Ghanaian History," in *African Art and Leadership,* edited by D. Fraser and H. M. Cole, pp. 173-83. University of Wisconsin Press, Madison.

Sieber, Roy, and Arnold Rubin

1968 *Sculpture of Black Africa: The Paul Tishman Collection.* Los Angeles County Museum of Art, Los Angeles, Calif.

Tauxier, Louis

1921 *Le Noir de Bondoukou.* E. Leroux, Paris.

Underwood, Leon

1948 *Masks of West Africa.* Alec Tiranti, London.

Vansina, Jan, R. Mauny, and L. V. Thomas, eds.

1964 *The Historian in Tropical Africa.* Oxford University Press, London.

Von Sydow, Eckart

1954 *Afrikanische Plastik.* George Wittenborn, New York.

Wilks, Ivor

1961 *The Northern Factor in Ashanti History.* Institute of African Studies, Legon.

1962 "A Medieval Trade Route from the Niger to the Guinea Coast," *Journal of African History,* Vol. 3, No. 2, pp. 337-41.

1968 "The Transmission of Islamic Learning in the Western Sudan," in *Literacy in Traditional Societies,* edited by John R. Goody. Cambridge University Press, London.

Williams, Drid

1968 "The Dance of the Bedu Moon," *African Arts/Arts d'Afrique,* Vol. 2, No. 1 (Autumn), pp. 18-21, 72.

Lenders to the Exhibition

Mr. and Mrs. Paul Gebauer, McMinnville, Oregon
Dr. and Mrs. Cecil A. Van Kleek, Portland, Oregon
Private Collection, Bellevue, Washington
Gallery Nimba, Seattle, Washington
Henry Art Gallery, Seattle, Washington
Portland Art Museum
Seattle Art Museum